BLACK AMERICA SERIES
BLACK BASEBALL IN PITTSBURGH

Chuck Berry was not referring to Josh Gibson (above) when he sang, "Rounding third he was heading for home / It was a brown eyed handsome man," but to Negro League fans, he might just as well have been. During the Negro League's heyday, Gibson was "Mr. Black Baseball" in the Steel City despite the 13 future Hall of Famers who played in the Negro Leagues in Pittsburgh.

Hall of Famers with Homestead Grays	Halls and Induction Years
1. Cool Papa Bell, 1932, 1943–46	U.S., 1974
2. Ray Brown, 1932–45	Puerto Rico, 1996; Cuba, 1998
3. Oscar Charleston, 1930–31	U.S., 1976; Cuba, 1997
4. Martin Dihigo, 1928	U.S., 1977; Cuba, 1951; Mexico, 1964
5. Willie Foster, 1931	U.S., 1996
6. Josh Gibson, 1929–31, 1937–40, 1942–46	U.S., 1972; Mexico, 1972; Puerto Rico, 1996
7. Judy Johnson, 1930, 1937	U.S., 1975
8. Buck Leonard, 1934–50	U.S., 1972
9. Luis "Angel" Marquez, 1946–48	Puerto Rico, 1991
10. Bob Thurman, 1946–48	Puerto Rico, 1991
11. Willie Wells, 1932	U.S., 1997
12. Smokey Joe Williams, 1925–32	U.S., 1999

Hall of Famers with Pittsburgh Crawfords	Halls and Induction Years
1. Cool Papa Bell, 1932–38	U.S., 1974
2. Oscar Charleston, 1932–38	Puerto Rico, 1996; Cuba, 1998
3. Willie Foster, 1936	U.S., 1996
4. Josh Gibson, 1932–36	U.S., 1972; Mexico, 1972; Puerto Rico, 1996
5. Judy Johnson, 1932–36	U.S., 1975
6. Satchel Paige, 1931–37	U.S., 1971; Puerto Rico, 1996

BLACK AMERICA SERIES

BLACK BASEBALL IN PITTSBURGH

Larry Lester and Sammy J. Miller

Copyright © 2001 by Larry Lester and Sammy J. Miller.
ISBN 0-7385-0531-5

First printed in 2001.

Published by Arcadia Publishing,
an imprint of Tempus Publishing, Inc.
2A Cumberland Street
Charleston, SC 29401

Printed in Great Britain.

Library of Congress Catalog Card Number: 2001086556

For all general information contact Arcadia Publishing at:
Telephone 843-853-2070
Fax 843-853-0044
E-Mail sales@arcadiapublishing.com

For customer service and orders:
Toll-Free 1-888-313-2665

Visit us on the internet at http://www.arcadiapublishing.com

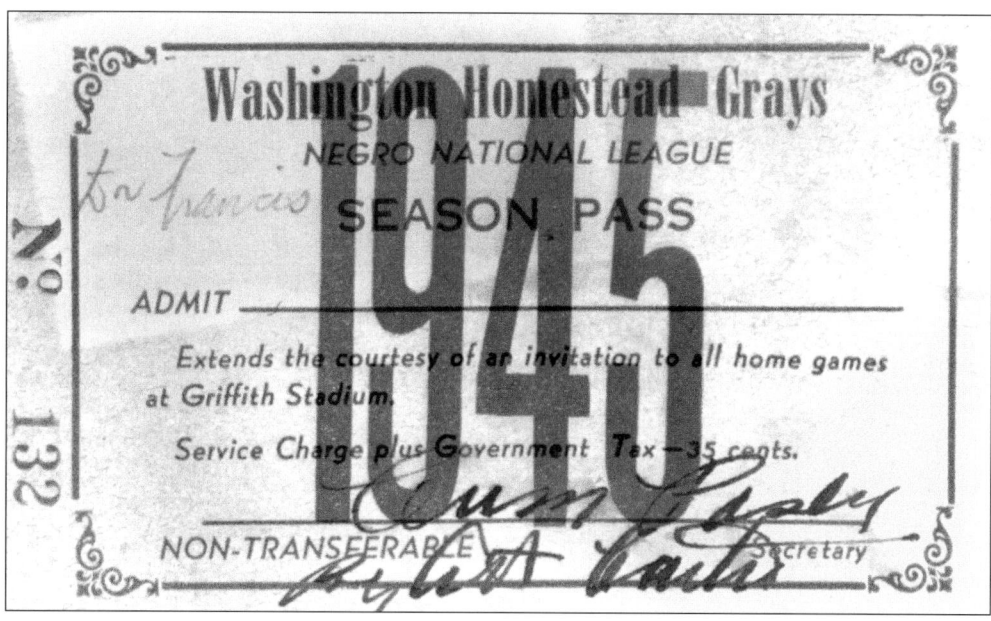

The 1945 Homestead Grays won the Negro National League pennant for the ninth consecutive time but lost the World Series to the Cleveland Buckeyes in four straight games. The team's feat of nine straight pennants has never been matched by any American sports team, black or white, making this 1945 Washington Homestead Grays season pass one of the most envied items of the time. The pass extended "the courtesy of an invitation to all home games at Griffith Stadium" in Washington, D.C.

CONTENTS

Introduction		7
Acknowledgments		8
1.	From the Sandlots to the Bigs	9
2.	The Crawfords Shine, the Grays Decline	25
3.	A Dynasty Begins	53
4.	The Beginning of the End	89
5.	Recognition Comes at Last	103
6.	The Hill District	115
7.	Weep Ye Not for the Dead	119
8.	Only Memories Remain	125

League Standings

HOMESTEAD GRAYS

YEAR	WON-LOST	PLACE FINISHED	MANAGER
American Negro League			
1929	34-29	Third	Cumberland Posey
1930–31 (Independent)			
East-West League			
1932	29-19	Second	Cumberland Posey
Negro National League			
1933	11-9	Dropped out July 11	Cumberland Posey
1934 (Independent)			
1935	23-23	Fourth	Vic Harris
1936	22-27	Sixth	Vic Harris
1937	—	First	Vic Harris
1938	—	First	Vic Harris
1939	33-14	First	Vic Harris
1940	28-13	First	Vic Harris
1941	25-17	First	Vic Harris
1942	26-17	First	Vic Harris
(World Series: lost to Kansas City Monarchs 4-0)			
1943	31-9	First	Candy Jim Taylor
(World Series: defeated Birmingham Black Barons 4-3)			
1944	27-12	First	Candy Jim Taylor
(World Series: defeated Birmingham Black Barons 4-1)			
1945	32-13	First	Vic Harris
(World Series: lost to Cleveland Buckeyes 4-0)			
1946	27-28	Third	Candy Jim Taylor
1947	—	Fourth	Candy Jim Taylor
1948	—	First	Candy Jim Taylor
(World Series: defeated Birmingham Black Barons 4-1)			
1949	—	—	Sam Bankhead
1950	—	—	Sam Bankhead

PITTSBURGH CRAWFORDS

YEAR	WON-LOST	PLACE FINISHED	MANAGER
East-West League			
1932	32-26	Third	—
Negro National League			
1933	38-17	Second	Oscar Charleston
1934	31-19	Second (tie)	Oscar Charleston
1935	26-6	First	Oscar Charleston
(Playoffs: defeated New York Cubans 4-3)			
1936	36-24	First	Oscar Charleston
1937	—	—	Oscar Charleston
1938	—	—	Oscar Charleston
United States League			
1945	—	First	Fred "Tex" Burnett
1946	—	—	Roy "Red" Parnell

INTRODUCTION

Pittsburgh is home to steel mills, the Carnegie family, Pittsburgh Plate Glass, the Golden Triangle business district, Duquesne University, and the meeting place of the Allegheny, Monongahela, and Ohio Rivers. Called "the Hearth of the Nation" for the red glow of its steel mills visible for miles at night, Pittsburgh is known across the country as a working man's city. The image of a hardworking individual sweating in the steel mills to help our nation during times of war and peace is familiar to every American. While those in the Steel City work hard, they also play hard, expecting the very best from its professional sports teams. Indeed, the very best is what they had when two of the greatest franchises in Negro League history called the city home.

One of the greatest teams in all of baseball was the Homestead Grays. During its history, the team won nine consecutive pennants, a record unsurpassed in sports. The Grays were originally called the Murdock Grays, a semiprofessional team managed by Terry Veney and sponsored by the Harbison-Walker Brick Yard and the Carnegie-Illinois Steel Mills. They became the Homestead Grays in 1911, the same year they were joined by collegiate Cumberland Posey Jr. By 1913, the local press reported that the Homestead nine won 42 games in a row. Posey became the team captain in 1916 and owner by the early 1920s.

In 1929, the Grays joined the American Negro League, but the crush of the Great Depression caused the league to collapse. Formed to play independent ball until 1932, a new league called the East-West was established by Posey and other owners. Despite their valiant efforts, the league folded mid-season.

The Grays fielded highly successful teams in 1930 and 1931. By 1932, however, the team was just a shell of its former self due to the player raids made by Gus Greenlee, the numbers king of Pittsburgh's black district, the Hill. Greenlee lured players from Posey's team and signed them to play for his new Pittsburgh Crawfords. Over the next few years, the Crawfords became one of the best franchises in Negro League baseball, winning pennants in 1935 and 1936. Greenlee's contributions to Negro League baseball were not limited to Pittsburgh, however. He was also responsible for the formation of the second Negro National League and the annual East-West all-star game, both of which debuted in 1933.

While the Negro National League lasted until 1948 and the East-West game went on until the early 1960s, the Crawfords' success was short lived. The decline of the Crawfords marked the rise of the Grays, as the Grays won the Negro National League pennant every year from 1937 through 1945.

In 1942, for the first time since 1927, the Negro League World Series was held, pitting the Grays against the Kansas City Monarchs. The Grays lost the series that year but won it the following two years with victories over the Birmingham Black Barons. The Homestead nine lost

the 1945 series to the Cleveland Buckeyes but returned in 1948 to capture the Negro League World Championship for a third time by again beating the Birmingham Black Barons.

The year 1945 marked the return to Pittsburgh of the Crawfords, who had played in Toledo in 1938 and Indianapolis the following year. This time around, they were part of the United States League, which was founded by Gus Greenlee and Branch Rickey. According to published reports, Rickey was trying to bring stability to the black baseball leagues. The truth was that Rickey was using the United States League and his entry into it, the Brooklyn Brown Dodgers, to scout the Negro Leagues for the man he would use to break the Major League's color barrier. He found that man in Jackie Robinson.

The debut of Robinson with the Dodgers in 1947 caused a mass exodus of fans from the Negro League to the majors. As a result, teams folded and leagues collapsed. After the Negro National League folded at the end of the 1948 season, the Homestead Grays carried on as an independent team before folding at the end of the 1950 season.

ACKNOWLEDGMENTS

We would like to thank the following people for their personal commitment and contributions to this wonderful chapter in African American history: Dick Clark, Erica Joi Lester, Jerry Malloy, and Gene and Barbara Miller. All photographs are courtesy of NoirTech Research unless otherwise noted.

This book is dedicated to the memory of Josh Gibson and Buck Leonard, two stars that were forced to shine in segregated skies, and to Jerry Malloy (1946–2000), a comrade, mentor, and the country's foremost authority on black baseball in the 19th century.

One
FROM THE SANDLOTS TO THE BIGS

The members of the 1913 Homestead Grays are, from left to right, as follows: (front row) Ben Pace, Jerry Veney, and Emmett Campbell; (middle row) Pete Peatros, Eric Russell, Cumberland Posey, Sel Hall, John W. Veney, Bob Hopson, and Hubert Sanders; (back row) Henry Saunders, Sam Smith, B.F. Alexander, Roy Horne, and Ralph Blackburn. The Grays were originally called the Murdock Grays and were sponsored by the Harbison-Walker Brick Yard and the Carnegie-Illinois Steel Mills. They became the Homestead Grays in 1911 and by 1913 were so good that, according to the local press, they won 42 games in a row. (Courtesy of the Carnegie Library, Pittsburgh, Pennsylvania.)

Cumberland Willis Posey Jr., who went on to make the Homestead Grays the Negro League equivalent of the New York Yankees, was born on June 20, 1880, in Homestead, Pennsylvania. Under his guidance, the Grays won 11 pennants, including nine consecutive Negro National League Championships (1937–45) and two World Championships (1943 and 1945). Posey, who played both football and basketball at Penn State University, first joined the Grays in 1911. He became team captain in 1916 and, by the early 1920s, was the owner of the team.

By the early 1920s, when this picture was taken, the Homestead Grays were one of the better-known independent teams in the eastern part of the country. Unlike some traveling teams, the Grays were in good shape financially and showed a profit every year from 1912 to 1929. This version of the team featured such players as Jasper Washington (back row, second from left) and Raymond "Mo" Harris (back row, far right). Harris later became an umpire in the Negro National League. (Courtesy of Luis Munoz.)

The legendary slugger John Beckwith, who at one time played every position on the diamond, first joined the Grays in 1924. Due to discipline problems, Beckwith was cut from the Grays halfway through the season. He returned in 1928, hitting 54 home runs that season. Beckwith played his last season with the Grays in 1929, when he hit .443 and had 15 home runs.

Elander "Vic" Harris joined the Grays as an outfielder in 1925. A left-handed spray hitter, Harris had a lifetime .299 average in the Negro Leagues. In 1929, when the Grays joined the American Negro League for its sole season of operation, Harris filled the leadoff spot and hit .333 for the season. "Vicious Vic," as he was known due to his competitiveness and love of fighting, stayed with the Grays until the end of the 1933 season.

Although he was 39 years old by the time he signed with the Homestead Grays in 1925, "Smokey" Joe Williams was still one of the best hurlers in all of baseball. By the time Williams joined the Grays, the half Native American, half African American did not have the blinding speed he once had, but his pinpoint control and cunning on the mound soon made him the ace of the Grays. He would fill that role until he retired from the game in 1933. Born in Seguin, Texas, on April 6, 1886, Williams began his professional career with the Chicago Giants in 1910. Said to be able to "cut your throat" with his fastball, Williams played for eight different teams before joining the Grays. According to teammates, catchers' hands would swell from being on the receiving end of Williams's overpowering pitches. (Courtesy of Jeff Eastland.)

A talented second baseman and a hitter who loved curve balls, George "Tubby" Scales joined the Homestead nine in 1925. He played with the team through the end of the 1926 season and then returned to the team twice more during his career (1929–31 and 1935). The 5-foot 11-inch, 195-pound Scales was not only at home at the keystone spot, but could also play first, third, shortstop, and the outfield.

In the 1920s, the Homestead Grays traveled to games in the bus pictured here. In the Negro Leagues, a bus was the player's home away from home. At times, players would have to eat and sleep on the bus while making all-night treks to a city where they were scheduled to play. (Courtesy of Jeff Eastland.)

Considered by some to have been the greatest Cuban baseball player of all time, Martin Dihigo spent the 1928 season with the Homestead Grays. While renowned as a pitcher, Dihigo also excelled at every infield position and the outfield as well. While with the Grays, the talented Cuban hit 18 home runs and had a .386 batting average.

Dihigo began his Negro League career in 1923 with the Cuban Stars of the Eastern Colored League and stayed with the team through the end of the 1927 season. While with the Stars, Dihigo led the league with home runs and hit .421 in 1926. He tied for the lead in 1927, hitting .370. Cumberland Posey claimed that "Dihigo's gifts afield have not been approached by any man—black or white."

Originally known as the Crawford Colored Giants after the Crawford Bath House on Bedford Avenue, the Pittsburgh Crawfords were one of the city's top sandlot teams. The members of this late 1920s team are, from left to right, as follows: (front row) William Smith, Tootsie Deal, ? Julius, Wyatt Turner, Reese Mosby, Bill Jones, Teenie Harris, and Johnny Moore; (back row) Nate Harris, Bill Harris, Harry Beale, Buster Christian, and Jasper Stevens. (Courtesy of the Carnegie Library, Pittsburgh, Pennsylvania.)

A member of the Pittsburgh Crawfords in the 1920s, Charles "Teenie" Harris never made it to the black Major Leagues as a player but played a large part in making sure the Negro League teams of Pittsburgh were remembered by future generations. After joining the *Pittsburgh Courier,* one of the nation's leading black newspapers, as a photographer in 1936, Harris prolifically recorded events in black Pittsburgh. Many of the images of black baseball in the city are the result of the work of "One Shot" Harris. (Courtesy of Teenie Harris.)

The 1929 Pittsburgh Crawfords, still a city sandlot team at this time, pose at Ammon Field on Bedford Avenue. Although Ammon Field was the home field of the Crawfords, the players were not allowed to use its locker rooms by order of the field's white manager. The team members are, from left to right, Neal Harris, Jimmie Hills, Harold Tinker, Johnny Moore, Josh Gibson, Howard Kimbro, Gilbert Hill, Claude Johnson, Bill Harris, Allie Thompkins, and Charles Hughes.

The members of the 1930 Homestead Grays are, from left to right, as follows: (front row) Vic Harris, Jake Stephens, Oscar Owens, Lefty Williams, George Britt, Bennie Charleston, and Oscar Charleston; (back row) Charlie Walker Jr., Raymond "Mo" Harris, William Ross, Buck Ewing, Joe Williams, George Scales, Judy Johnson, and Cumberland Posey. This team later won the Eastern Championship during a season in which they were involved in two incidents that would take on legendary proportions—the signing of Josh Gibson and a pitching duel between Joe Williams and Chet Brewer

Third baseman Judy Johnson became a member of the Homestead Grays in 1930. Considered to be the greatest third baseman of his day, Johnson was a master defensive player and strong hitter who was best in the clutch. Johnson hit .288 that season as a player-manager. A native of Snow Hill, Maryland, Johnson began his career in 1918 with the Atlantic City Bacharach Giants. In 1921, he joined the Hilldale Daisies and was instrumental in the team's three consecutive pennants (1923–25) and its World Championship in 1925. (Courtesy of Todd Bolton.)

Josh Gibson is remembered as the greatest black slugger of all time. The beginning of his professional career came in 1930 during a night game at Forbes Field, under the portable lights of the Kansas City Monarchs. At one point in the game, Homestead Grays catcher Buck Ewing and pitcher Smokey Joe Williams got their signals crossed. Ewing, finding himself with an unexpected pitch, wound up with a split finger and was unable to continue. Since the Grays did not have another catcher on the bench, the Grays turned to Vicious Vic Harris. But the man who was thought to fear nothing refused to catch Joe Williams. Grays manager Judy Johnson then put a call out to some local sandlot players for a catcher and was quickly answered by a 6-foot 1-inch, 210-pound Josh Gibson. (Courtesy of the National Baseball Hall of Fame Library, Cooperstown, New York.)

The legendary Oscar Charleston joined the Grays in 1930, hitting .380 that season. He is considered by some to be the greatest player in the history of baseball, black or white. He could do it all on the field. He had good speed, could hit for both average and power, and was an exceptional fielder. Remembered as one of the "four big bad men" of black baseball, Charleston had a drive to win that was only excelled by his love of a good fight. As a native of Indianapolis, Indiana, he had begun his career with the Indianapolis ABC's in 1915. He played for a total of seven teams before moving to the Grays in 1930. That season would be the first of many Charleston would spend in Pittsburgh.

The brother of famed Negro League pitcher Andy Cooper, Darltie Cooper pitched for the Homestead Grays in 1930. Although he was a talented pitcher, reports hold that managers had trouble keeping him in shape, and he switched teams often. During his career, which stretched from 1923 to 1940, Cooper played for eleven different Negro League teams, never playing more than three consecutive seasons for any of them.

George Scales, second baseman for the Grays during the 1930 and 1931 seasons, filled the role of batting behind Josh Gibson. An argument between Scales and Ted Page shows how determined Negro League teams were when it came to winning. After Scales commented on Page's poor performance, Page knocked out two of Scales's teeth. Although the fight was broken up, the two slept that night with weapons in their hands—Scales with a knife and Page with a gun. (Courtesy of Luis Alvelo.)

On August 30, 1930, at a game between the Homestead Grays and the Kansas City Monarchs, one of the greatest pitching duels in the history of baseball took place. The 44-year-old "Smokey" Joe Williams was on the mound for the Grays while Chet Brewer toed the rubber for the Monarchs. At an age when most players are long retired, Williams held the Monarchs hitless through seven innings. In the eighth, Williams gave up a double to the Monarchs' third baseman, Newt Joseph. It would be the team's only hit. Williams and Brewer continued to shut out the opposing team until the top of the 12th inning, when the Grays were able to put one run on the board. Williams kept the Monarchs in check in the bottom of the 12th for the win. The final tally for Williams that day was a one-hit shutout with 27 strikeouts in 12 innings.

The 1931 Homestead Grays are regarded as one of the greatest collections of talent in the history of sports. The team members are, from left to right, as follows: (front row) George Britt, Lefty Williams, Jud Wilson, Vic Harris, Ted Radcliffe, and Ted Page; (back row) Cumberland Posey, Bill Evans, Jap Washington, Red Reed, Joe Williams, Josh Gibson, George Scales, Oscar Charleston, and Charlie Walker Jr. In addition to an unrivaled level of playing talent, this team featured the "four big bad men" of black baseball—Britt, Harris, Wilson, and Charleston—and won the franchise its second Eastern Championship in two years. (Courtesy of the National Baseball Hall of Fame Library, Cooperstown, New York.)

The swing of Josh Gibson became legendary in 1931, when he hit 75 home runs. Gibson had a peculiar flat-footed stance and avoided overstriding when he swung. In addition to his four-baggers, he set another milestone that season when he faced a white Major League pitcher for the first time, George Uhle of the Detroit Tigers. Gibson went to the plate six times in the exhibition game and collected four hits, two singles, and two home runs. (Courtesy of the Moorland-Spingarn Research Center, Howard University.)

One of the greatest natural hitters in the Negro Leagues was Ernest Judson "Jud" Wilson. Wilson joined the Grays in 1931, adding his lethal bat and a .323 season average to an already potent lineup. A line drive hitter, Wilson reportedly earned his nickname "Boojum" from the sound his hits made when they struck the outfield fence. Reputed to have been tough enough to "go bear hunting with a switch," Wilson was one of the most determined and savage personalities that the game has ever seen. Off the field, however, he was regarded as a "giant teddy bear."

A major part of the Grays pitching staff of 1931 was the big left-hander Bill Foster, who played for two World Championship teams with the Chicago American Giants in 1926 and 1927. Foster went 7-1 for the Grays that year using his pinpoint control and vast array of pitches that included a fastball, slider, drop ball, side arm curve, and a change-up. Foster played with the Grays until September, when he joined the Monarchs.

Ray Brown, a highly talented pitcher with a large arsenal of pitches, joined the Homestead Grays in 1932. Brown had a blazing fastball but is best remembered for his curve, which he threw with such control that it was an effective 3-0 pitch. He started his professional career with the Dayton Marcos in 1930. He then played in Indianapolis and Detroit before moving to the Grays, where he would spend the rest of his career as one of black baseball's most dominating pitchers. (Courtesy of Luis Alvelo.)

Able to circle the bases in 12 seconds flat, a distance of 120 yards, James Thomas "Cool Papa" Bell was the fastest man ever to play the game. Bell brought his fleet-footed wizardry to the Homestead Grays in 1932. In addition to his speed and sure-handedness in the field, the switching hitter Bell shined at the plate, regularly hitting over .300. He hit .384 his first year with the Grays.

Two
THE CRAWFORDS SHINE, THE GRAYS DECLINE

Although things were going well for Cumberland Posey and his Homestead Grays in 1931, the entrance that year of another black team in Pittsburgh would prove to be a dark day for his team. William A. "Gus" Greenlee fielded his first professional version of the Pittsburgh Crawfords, a former sandlot team that he funded in 1930. Greenlee, who came to Pittsburgh after World War I, had money to spare as the undisputed numbers king of black Pittsburgh. (Courtesy of the Carnegie Library, Pittsburgh, Pennsylvania.)

Wylie Avenue was the heart of the Hill, Pittsburgh's black district. Shown on the left is the Crawford Grill, the home of Gus Greenlee's business enterprises. It included a stable of boxers as well as numbers runners, bootleggers, and prostitutes. Residents of the Hill often overlooked his questionable activities because Greenlee regularly invested his profits back into the community. (Courtesy of Teenie Harris.)

Located on Wylie Avenue across the street from the Crawford Grille (visible through the front door) was the Crystal Barbershop, owned by Woogie Harris. An associate of Greenlee, Harris helped "Big Red," as Greenlee was known, to make the lottery numbers into one of the biggest businesses in the Hill. The money that Greenlee gained from the lottery game, which was popular in cities across the country, would thrust the Hill and Wylie Avenue into the forefront of black baseball. (Courtesy of Teenie Harris.)

Already a fan favorite and major drawing card, Leroy "Satchel" Paige (shown second from the left in the Crawford Grill) joined the Pittsburgh Crawfords in 1931 after having started the season with the Cleveland Cubs. That June, the tall lanky pitcher with the blazing fastball was on the mound for the Crawfords when the team defeated its rival, the Homestead Grays, for the first time with a score of 6-5.

As Satchel Paige's favorite catcher, William "Cy" Perkins joined the Crawfords in 1931, taking with him his chest protector that bore the warning, "Thou shalt not steal." Overall, Perkins was a good catcher with a strong arm and a consistent hitter, although he was slow afoot on the bases. He remained with the Crawfords through the 1936 season, with the exception of a short stint with Homestead Grays in 1932.

27

For a short time in 1931, one of the greatest pitchers in black baseball, "Cannonball" Dick Redding (right), played for the Crawfords. He is shown here with Smokey Joe Williams. Although the 40-year-old Redding was past his prime by then, his name alone could still draw a crowd.

Gus Greenlee (center) had reason to smile when this picture was taken in 1932. Before the season, Big Red had opened his substantial wallet and brought together some of the greatest talent the game had seen to play for his Pittsburgh Crawfords. Cumberland Posey and his Homestead Grays were particularly hard hit by Greenlee's great player hunt. Posing with Greenlee are, from left to right, Louise Harris, Helen Greenlee (Gus Greenlee's wife), Ada Harris, and an unidentified woman.

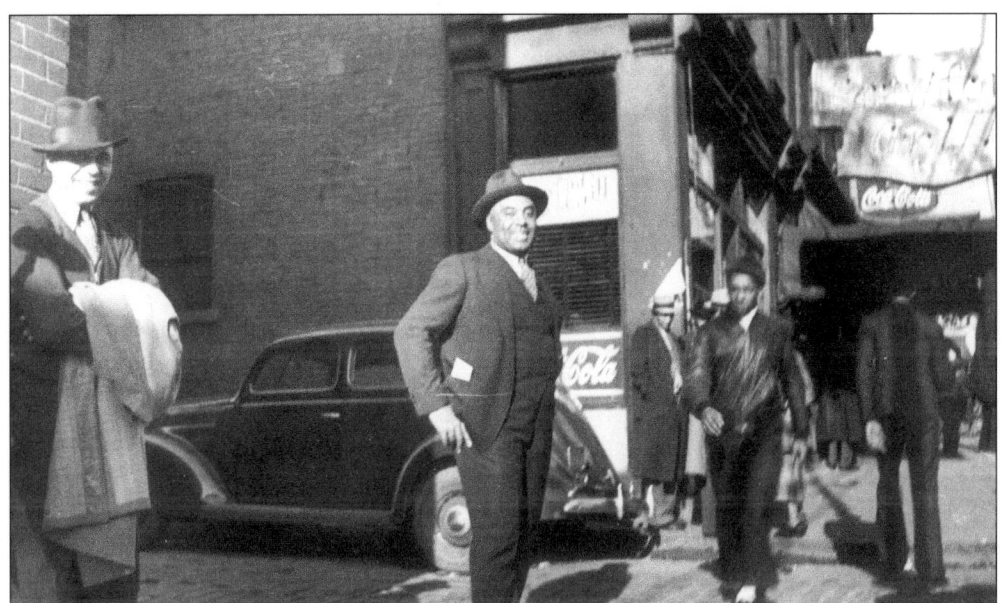

As with any new sports team, the first piece needed is a manager. To find one for his Crawfords, Greenlee traveled to Homestead and signed Oscar Charleston away from the Grays. It was an excellent choice by Big Red; Charleston had a great baseball mind and was universally respected by players. The 36-year-old Charleston, shown here outside the Crawford Grill, went on to hit .363 for the Crawfords that season. He remained the team's player-manager throughout the team's years in Pittsburgh. (Courtesy of Teenie Harris.)

One of Oscar Charleston's first acts as manager of the Pittsburgh Crawfords was to convince slugger Josh Gibson, famous for his home run–hitting prowess, to go with him to Greenlee's team. Other Homestead players that followed Gibson to the Crawfords were Ted Page, Ted Radcliffe, Jud Wilson, and Jake Stephens. Gibson excelled with the new team, hitting 34 home runs and batting .380 for the 1932 season.

Herbert "Rap" Dixon, a great defensive outfielder who could hit for both average and power, joined the Pittsburgh Crawfords in 1932. Dixon, who was born in Kingston, Georgia, on September 2, 1902, began his professional career with the Harrisburg Giants in 1922. In 1927, while still with the Giants, he was part of a group of Negro Leaguers that traveled to the Orient as baseball ambassadors. In Japan, Dixon hit a home run that was said to be the longest ever hit in the island nation. The emperor honored him with a cup for his on-field display. Regarded as one of the best hitters in black baseball during the 1920s and 1930s, he hit .343 with 15 home runs in 1932. He left the Crawfords in 1933 but returned in 1934.

The members of the 1932 Pittsburgh Crawfords are, from left to right, as follows: (front row) Sam Streeter, Chester Williams, Harry Williams, Harry Kincannon, Henry Spearman, Jimmie Crutchfield, Bobby Williams, and Ted Radcliffe; (back row) Benny Jones, L.D. Livingston, Satchel Paige, Josh Gibson, Ray Williams, Walter Cannady, Cy Perkins, and Oscar Charleston. An independent team for that season, the Crawfords finished the year with a record of 99 wins and 36 losses.

Gus Greenlee had new stationery printed up for his new Pittsburgh Crawfords in 1932. The stationery bore pictures of the team's bus as well as a number of players. It names Walter "Rev" Cannady as the "best all-around player in baseball," labels Josh Gibson as the "hardest hitter in Negro baseball," and declares Satchel Paige as "the Speed Ball King."

In 1932, while with the Pittsburgh Crawfords, Ted Radcliffe (shown in his later years tagging out Josh Gibson) gained the nickname that he is still known by today. In a doubleheader at Yankee Stadium, Radcliffe caught a shutout pitched by Satchel Paige in the first game and then pitched a shutout himself in the second game. Famed writer Damon Runyon attended both games and christened Radcliffe as "Double Duty" in his column the next day.

Radcliffe, who played for the Homestead Grays in 1931, remained with the Crawfords for only one season before this one-man pitching and catching show came back to the Grays in 1933. On the road again in 1934, Radcliffe returned to the Steel City to play for the Grays in 1936 and 1946.

By 1932, the stories of Josh Gibson's hitting prowess were already reaching mythical proportions. One such story said that during a game in Pittsburgh, Gibson hit a ball that disappeared from sight and was ruled a home run. The next day, a ball dropped from the sky into the hands of the opposing fielder in Philadelphia, causing the umpire to tell Gibson, "You're out, yesterday in Pittsburgh."

Gibson did indeed make balls fly from parks across the country, and this power posed a danger to fielders. Crawford teammate Ted Page remembered, "I believe the Crawfords were playing in York, Pennsylvania. Josh hit a blistering liner right at Willie Wells. Now, Wells was a great shortstop, but he couldn't do anything with that ball. It hit his glove so hard it split the skin of his left hand. Remember, that was a tough hand, callused by catching a lot of balls."

Wanting a place for his team to play, Gus Greenlee built Greenlee Park at 2500 Bedford Avenue in Pittsburgh. The park sat west of Municipal Hospital and east of what remained of Lincoln Cemetery after Greenlee had part of the cemetery razed to build the park. The stadium, which was surrounded by high red brick walls, cost between $75,000 and $100,000 to build and took 14 train cars of cement, 75 tons of steel, and 1,100 linear feet of steel fencing. A total of 21,000 cubic yards of ground were excavated for the site.

Satchel Paige was on the mound for the park's first game on April 29, 1932, when the Crawfords lost to the New York Black Yankees by a score of 1-0. Paige later redeemed himself at the park on July 16, 1932, when he pitched a no-hitter against the same Black Yankees. In August of that year, Greenlee added lights, making his park the first in the country to offer regular night games. This picture was taken during the first night game played at Greenlee Field.

"It [Greenlee Field] was beautiful. It had lots of grass and you almost felt like you were playing in a major league park. The best thing for me was the big outfield. It gave me lots of room to run.

"Gus really did his best to run a class organization. We had a fine bus, nice uniforms, good equipment, everything." —James "Cool Papa" Bell. (Courtesy of Teenie Harris.)

Judy Johnson joined the Pittsburgh Crawfords in 1932 as team captain and stayed with the team through the end of the 1936 season as the team's starting third baseman. A lifetime .309 hitter, Johnson proved to be an integral part of the great Crawfords teams of the 1930s, including the 1935 "super team." Traded to the Homestead Grays along with Josh Gibson in 1937, Johnson retired from baseball that year. (Courtesy of the National Baseball Hall of Fame Library, Cooperstown, New York.)

Standing in front of the Pittsburgh Crawfords team bus are, from left to right, two unidentified men, Helen Greenlee, Ada Harris, Louise Harris, George Harris, Oscar Charleston, Josh Gibson, and an identified bus driver. The bus (below) was the final piece of Greenlee's spending spree in 1932. That team was the first of the Crawfords teams that dominated black baseball for the next several years. (Courtesy of the Mack Trucks Historical Museum.)

Forbes Field, the home of the Pittsburgh Pirates and Homestead Grays, was the site of a history-making event on May 7, 1932, when a "double league" doubleheader was played. The first game was between the Pirates and the Philadelphia Phillies. The second game pitted the Grays against the Philadelphia Hilldales. The game was just one of many famous Negro League events that transpired at Forbes Field, the site of Josh Gibson's first Negro League game. (Courtesy of the Carnegie Library, Pittsburgh, Pennsylvania.)

By 1933, the Homestead Grays were struggling, stripped of all their major stars. One of a handful of players that remained loyal to Posey and the Grays was pitcher Ray Brown, shown here about to score a run. The previous year, Posey had formed the East-West League, but it collapsed halfway through the season. (Courtesy of the National Baseball Hall of Fame Library, Cooperstown, New York.)

Although 1933 was a year of economic hardship for the rest of the country, Gus Greenlee's meteoric rise to the top of black baseball continued. That year, Greenlee formed the second Negro National League, which was made up of his Pittsburgh Crawfords as well as Cole's American Giants, the Baltimore Black Sox, the Nashville Elite Giants, the Detroit Stars, the Columbus Blue Birds, and (for a very short time) the Homestead Grays. The president of the league was, of course, Gus Greenlee. The year 1933 also saw the premier of Greenlee's greatest success, the East-West all-star game, which was held each year at Comiskey Park in Chicago. The game proved to be Greenlee's biggest contribution to baseball.

In 1933, the exodus of players from Posey's Grays to Greenlee's Crawfords continued when Cool Papa Bell made the trip. Bell hit .362 that year. This picture of Bell with the Crawfords shows the speed that made him famous. The arrow shows where the unfielded baseball lies as Bell steps on first. Ted Radcliffe once claimed that if Bell "bunts and it bounces twice, put it in your pocket."

Pittsburgh Crawfords manager Oscar Charleston was named the manager of the East team in the first East-West all-star game in 1933, which was played at Comiskey Park in Chicago before a crowd of 19,568 fans. The East team included Crawfords Josh Gibson, Judy Johnson, John H. Russell, Sam Streeter, and Bertrum Hunter as well as Homestead Grays Vic Harris and George Britt. The West team won the 1933 game by a score of 11-7.

The 1934 Pittsburgh Crawfords, shown here at Yankee Stadium, are, from left to right, Jimmie Crutchfield, Bertrum Hunter, Roosevelt Davis, Leroy Morney, Chester Williams, Cy Perkins, Clarence Palm, William Bell, Cool Papa Bell, Harry Kincannon, Judy Johnson, Leroy Matlock, Ted Page, Curtis Harris, Josh Gibson, Satchel Paige, and Oscar Charleston. In league play that year, the Crawfords went 29-17 but failed to win the pennant. (Courtesy of Jimmie Crutchfield.)

After witnessing the struggles of his team to make ends meet while Greenlee's Crawfords flourished, Cumberland Posey decided to bring in a partner for the Grays in 1934. The man he turned to was Rufus "Sonnyman" Jackson, the owner of the Sky Rocket Grille in Homestead (below). Jackson had made vast amounts of money in the piccolo business and the numbers racket. He became president and treasurer for the Grays while Posey filled the role of general manager.

Although it has never been verified through a box score, many claim that Josh Gibson accomplished a feat no other human ever matched. According to former Chicago American Giant Jack Marshall, "in 1934, Josh Gibson hit a ball off of Slim Jones in Yankee Stadium in a four team double header that we had there—the Philadelphia Stars played the Crawfords in the second game; we had played the Black Yankees in the first game. They say a ball has never been hit out of Yankee Stadium. Well that is a lie! Josh hit the ball over the triple deck next to the bullpen in left field. Over and out!"

For the record, the *Sporting News* of June 3, 1967, credited Gibson with a home run in Yankee Stadium that hit just below a wall in center field, some 580 feet from home plate. That would be the longest home run ever hit in the stadium.

Shown from left to right are four members of the 1934 Crawfords: Oscar Charleston, Josh Gibson, Ted Page, and Judy Johnson. Page, a great all-around player who was equally effective in the outfield and at the plate, would do anything to win; he was known for using his spikes to ensure that he reached base safely. In the off-seasons, Page would sit in front of the Crawford Grill as a lookout while the proceeds from Greenlee's numbers rackets were being counted. (Courtesy of the National Baseball Hall of Fame Library, Cooperstown, New York.)

Matthew "Lick" Carlisle, shown here running for first, joined the Homestead Grays in 1935. Hitting .326 that year, Carlisle was a fine defensive second baseman with good speed. He stayed with the Grays through the end of the 1944 season as one of the team's top base thieves. After serving a year in the armed services, he returned in 1946 for the final year of his career. (Courtesy of the National Baseball Hall of Fame Library, Cooperstown, New York.)

Another addition to the Homestead Grays in 1935 was Norman "Jelly" Jackson. A talented shortstop with a good throwing arm, Jackson shored up the team's defense for the next six years. While he had good speed and was an effective base runner, Jackson was a less talented hitter. His best season average was .265 in 1939. However, Jackson did supply offensive help to the Grays and is remembered as one of the best at getting a crucial run in close games.

Josh Gibson (right) poses here in San Juan with teammate Ted Page. Gibson is credited with having hit one of his longest home runs while playing in the island nation's winter season of 1934–35. According to Ted Page, Gibson "hit an awful long ball, over the center field fence and right there on the beach. There was a lot of wind and the fence was 475 feet, and he hit it another 50 feet beyond that. The ball had to travel at least 500 to 525 feet." (Courtesy of Josh Gibson Jr.)

The 1935 Crawfords are, from left to right, as follows: (front row) Tim Bond, Carl Howard, Bert Hunter, Sam Streeter, Harry Kincannon, and Rosey Davis; (middle row) Cool Papa Bell, Sam Bankhead, Oscar Charleston, Clarence Palm, Jimmie Crutchfield, Spoon Carter, and Cy Perkins; (back row) Jelly Taylor, Judy Johnson, Leroy Matlock, Roy Kincannon, Josh Gibson, and Hood Witton. This team went on to defeat the New York Cubans for the Negro National League pennant. (Courtesy of Pamela Paige O'Neal.)

On August 24, 1935, the Pittsburgh Crawfords and the Chicago American Giants set a new record for the longest game in black baseball. The game, played in Chicago, lasted 19 innings. Crawford Cool Papa Bell, shown here, had six hits and scored three runs in the game. The Crawfords won by a score of 11-8. Another high achiever for the Crawfords that day was third baseman Curtis Harris, who had three hits and scored two runs.

The 1933–35 Pittsburgh Crawfords pitchers are, from left to right, Satchel Paige, Leroy Matlock, William Bell, Harry Kincannon, Sam Streeter, and Bertrum Hunter.

Remembered as one of the Negro League's greatest spitballers, Sam Streeter joined the Crawfords in 1931 and was the ace of the staff until the arrival of Paige later that same year.

William Bell joined the Crawfords in 1932 after spending time with the Detroit Wolves and the Homestead Grays that same season. Bell and his excellent control had been a major part of the pennant-winning Kansas City Monarchs in 1924 and 1925.

Leroy Matlock first donned a Pittsburgh Crawford uniform in 1933 and stayed with the team through the 1938 season. One of the top "lefties" in black baseball in the 1930s, Matlock had a vast array of pitches and great control. These two facets of his game helped him win 19 games in 1936. (Courtesy of the National Baseball Hall of Fame Library, Cooperstown, New York.)

In 1935, Satchel Paige grew tired of the frequent salary disputes he had with Gus Greenlee and jumped the Crawfords to play for a white semiprofessional team in Bismarck, North Dakota. Paige pitched 150 games in Bismarck and won 134 of them. The following season, he was back with the Crawfords, where he had a 26-3 record on the mound.

In 1935, the Crawfords defeated the New York Cubans, led by Hall of Famer Martin Dihigo, for the Negro National League pennant in a best-of-seven series. Dihigo is credited with a home run that landed on the roof of the hospital behind the right field fence. The roof of the building can be seen in the left-hand corner of this picture. (Courtesy of Teenie Harris.)

47

With the 1935 playoffs tied at three games apiece, the New York Cubans put Luis Tiant (father of future Boston Red Sox pitcher Luis Tiant Jr.) on the mound. In the eighth inning, with the Cubans leading 7-5, Josh Gibson hit a home run to make it 7-6. Oscar Charleston, shown here batting, then came to the plate and hit another home run to tie the game. Eventually, a single by Cool Papa Bell helped Sam Bankhead score, winning the title for the Crawfords. (Courtesy of Teenie Harris.)

After the Crawfords won the pennant in 1935, Gus Greenlee threw a championship dinner to celebrate the victory. Shown here, from left to right, are some of those who attended: (front row) Ferdinand Morton (Negro National League commissioner), Alex Pompez (New York Cubans owner), Gus Greenlee, Effa Manley (Brooklyn Eagles owner), and Josh Gibson; (back row) John Clark (Pittsburgh Crawfords business manager), Romeo L. Dougherty (writer), Abe Manley (Brooklyn Eagles owner), Candy Jim Taylor, Oscar Charleston, and an unidentified man.

Gus Greenlee's interest in sports did not end with baseball. He also had a stable of boxers. The boxers are, from left to right, unidentified, Oscar Charleston, John Henry Lewis, Satchel Paige, and Josh Gibson. On Halloween in 1935, John Henry Lewis became the undisputed light heavyweight champion by defeating Bob Olin in St. Louis. It was the first racially mixed championship fight in Missouri. At the time, Lewis was the only boxing champion in the country with an African American manager.

By the 1935 season, the Crawfords games at Greenlee Field were the most important social events in Pittsburgh's black district, the Hill. While adults dressed in their Sunday finery to attend games, children of the city's most affluent black citizens dressed like this boy, Woogie Harris's son. To black youths across the country in the 1930s, the Crawfords were the equivalent of the New York Yankees. (Courtesy of Teenie Harris.)

49

The Homestead Grays finished sixth in the Negro National League in 1936, a year that saw few high points for the team. It was one of two years (the other being 1934) in which a member of the Grays did not play in the East-West all-star game. In this photograph, Buck Leonard of the Grays makes the play at first. (Courtesy of the Moorland-Spingarn Research Center, Howard University.)

Posing in front of the team bus at Greenlee Field are the 1936 Pittsburgh Crawfords. The players are, from left to right, Oscar Charleston, Jimmie Crutchfield, Dickie Seay, Sam Bankhead, Bill Harvey, Sam Streeter, Cy Perkins, Chester Williams, Theolic Smith, Harry Kincannon, Judy Johnson, Cool Papa Bell, Leroy Matlock, Spoon Carter, Josh Gibson, Jasper Washington, Satchel Paige, and Duncan Escota. Partially visible on the far right is Wendell Pearson, the team's secretary. (Courtesy of Tweed Webb.)

The Crawfords outfield of 1936 was said to be so fast that raindrops could not fall between them. They are, from left to right, Sam Bankhead, Cool Papa Bell, and Jimmie Crutchfield. Bankead, one of five brothers to play in the Negro Leagues, was one of the most versatile players ever to don a uniform. By the time his career ended, he had appeared in nine East-West all-star games at five different positions while hitting .387.

Josh Gibson had the best season of his career in 1936. In league games, Gibson had a batting average of .457 and led the league with 11 home runs in official games. That year, Gibson played in 170 games and blasted an astounding 84 home runs. As a team, the Crawfords finished in first place in the second half of the split season. (Courtesy of Luis Alvelo.)

Instead of playing a series to determine a Negro National League champion for 1936, the Pittsburgh Crawfords and the Washington Elite Giants joined forces. Adding a few Homestead Grays, they headed west to participate in the Denver Post National Semi-Pro Tournament. The team won all seven of the games they played in and took the championship.

Above, the members of the 1936 Denver Post team are, from left to right, as follows: (front row) Paul Hardy, Bob Griffith, Satchel Paige, Ray Brown, Sam Streeter, Josh Gibson, and ? Horne (bat boy); (middle row) Hood Witton (trainer), Buck Leonard, Chester Williams, Cool Papa Bell, Felton Snow, Jack Marshall, and Candy Jim Taylor; (back row) Seward Posey, Sammy T. Hughes, Vic Harris, Bill Wright, and Orlando Hart (bus driver). (Courtesy of Jay Sanford.)

Three
A DYNASTY BEGINS

With the election of a reform-minded government in Pittsburgh, Gus Greenlee's lucky star began to fall. In repeated police raids, Greenlee's profits from his numbers racket were seized, putting a severe strain on his wallet. When the players were informed that they had to pay their own expenses for spring training in 1937, many went looking for a better deal. This photograph shows Greenlee in his Crawford Grill. (Courtesy of Teenie Harris.)

After Greenlee suffered financial difficulties, many of the Crawfords found a better deal in the form of an offer from another country. Every major star on the Crawfords jumped the team, including Satchel Paige, Cool Papa Bell, and Sam Bankhead. This left an aging Oscar Charleston behind to carry the team, which ended the 1937 season in fifth place. Shown here is Charleston (right) with the Crawfords business manager John Clark.

Rap Dixon (center) played for the 1935 New York Cubans that battled the Pittsburgh Crawfords for the Negro National League title. The following year, Dixon played for the Homestead Grays and spent a short time with the Crawfords again in 1937. Suffering from consumption, Dixon was only a part-time player during those years. He died of a heart attack in 1944 at the age of 42. This picture shows Dixon with Neil Pullen (left) and Crush Holloway.

In an effort to secure his place in an upcoming election, Pres. Rafael Trujillo of the Dominican Republic raided Gus Greenlee's championship Crawfords in a replay of Gus's raids on the Homestead Grays five years earlier. Those players are shown, from left to right, as follows: (front row) Lazaro Salazar, Tetelo Vargas, S. Alvarado, Silvio Garcia, Sam Bankhead, Harry Williams, and Perucho Cepeda; (back row) Cy Perkins, Enrique Latiqua, Cool Papa Bell, Toni Costano, Josh Gibson, Rodolfo Fernandez, Bob Griffith, and Satchel Paige.

After a slow start, several losses, and the players reportedly fearing for their lives at the hands of Trujillo's personal guards, the Trujillo All-Stars won the championship and fled the country the following day. Trujillo won the election and went on to become one of the most feared dictators in Latin America before being gunned down on May 30, 1961. (Courtesy of Luis Munoz.)

In 1937, Hall of Fame sportswriter Wendell Smith joined the *Pittsburgh Courier,* one of the nation's leading black weekly newspapers. Smith went on to become famous for his reporting on the Negro Leagues as well as being an outspoken voice for the integration of the Major League. In 1945, when the Brooklyn Dodgers signed Jackie Robinson, Smith became one of Robinson's most vocal supporters in the press as well as his confidant and roommate while the team was on the road.

In 1937, the Homestead Grays became the Washington Homestead Grays when they officially adopted Griffith Stadium in Washington, D.C., as their second home field. This move was an attempt to capitalize on the fans of the Washington Elite Giants, which had moved to Baltimore the same year. The team would play in Forbes Field (shown here) when the Major League Pittsburgh Pirates were on the road, and in Griffith Stadium when the Major League Washington Senators were traveling. (Courtesy of Teenie Harris.)

After returning from his time in the Dominican Republic, Josh Gibson rejoined the Homestead Grays for the second half of the split season. Shown from left to right are the players of the pennant-winning 1937 Grays: (front row) Tommy Dukes, Jelly Jackson, Matt Carlisle, Roy Welmaker, Lou Dula, Vic Harris, Arnold Waite, and Jerry Benjamin; (back row) Buck Leonard, unidentified, Jose Perez, unidentified, Tom Parker, Jim Williams, Josh Gibson, Ray Brown, and Edsall Walker. (Courtesy of the National Baseball Hall of Fame Library, Cooperstown, New York.)

After the 1937 regular season, the Grays and Josh Gibson went on a barnstorming tour in which they played an exhibition game against a team made up of Cincinnati Reds. Leo Durocher later remembered, "I played against Josh Gibson in Cincinnati, and I found out everything they said about him was true, and then some. He hit one of the longest balls I've ever seen. He caught hold of one of Weaver's fast ones, and I'll bet you it's still sailing." (Courtesy of Teenie Harris.)

Pitcher Ray Brown (left) is shown here with his Santa Clara teammate Johnny Taylor. Brown won 28 straight games for the Grays during the 1936 and 1937 seasons. In the 1936–37 Cuban winter season, while he was with Santa Clara, Brown led the league in wins with a record of 21-3. This included a 7-0 no-hitter against the Habana Reds on November 7, 1936. Cuba was a popular place for Negro Leaguers to play during the off-season because they faced little racial discrimination there. (Courtesy of Jeff Eastland.)

The last high point in the Crawfords story of the 1930s came at the sixth annual East-West all-star game in Chicago in 1938. That year, Oscar Charleston (shown at right with Andy Cooper, manager of the West squad) managed the East team. While the East team was loaded with Crawfords just two years before, only two members played in 1938. The East team lost that year by a score of 5-4. (Courtesy of John Holway.)

Carl "Bootnose" Smith joined the Pittsburgh Crawfords in 1938 as a catcher and third baseman. A good defensive player who usually batted low in the lineup, he started his career with the Birmingham Black Barons before moving on to the Homestead Grays. In addition to his catching responsibilities, Smith also played third base. (Courtesy of Carl Smith.)

Greenlee's fall from the throne as the king of black baseball in Pittsburgh reached its lowest point in 1938, the last year the Crawfords would call the city home. On December 10, 1938, the demolition of Greenlee Field began. In 1939, the Crawfords played out of Toledo and, the year after, in Indianapolis. Today, the site of the stadium is occupied by the Pittsburgh Housing Authority Projects. (Courtesy of Teenie Harris.)

Cool Papa Bell joined the Mexican League in 1938 and played there through the end of the 1941 season. Bell was elected to the all-star team in 1939, but his best year in Mexico was 1940, when he split the season between Veracruz and Torreon. Bell won the Triple Crown that year with a .437 batting average, 12 home runs, and 79 RBIs. He also led the league with 15 triples and 119 runs scored.

Under Vic Harris (shown at left with Buck Leonard, who returned to the Grays in 1935 as player-manager), the 1938 Grays captured their second Negro National League pennant in two years. The return of Josh Gibson in 1937 had supplied the team with the final piece it needed to become a top-notch ball club. Holding a position of authority, however, did nothing to calm "Vicious Vic." Throughout his career, he was still one of the most feared men in all of baseball. Harris's legendary "mean streak" is evident in an incident that happened while he was driving a car filled with players. After one of the players made a comment that he found offensive, Harris pulled over, dragged the man from the car, and pummeled him on the spot.

In 1938, pitchers in the Negro National League had to alter the way they faced the Homestead Grays because the "Thunder Twins"—Buck Leonard (shown) and Josh Gibson—batted back-to-back in the lineup that year. According to pitcher Dave Barnhill, "you could strike Josh out; you might throw a fastball by him. But Buck Leonard, you could put a fastball in a 30-30 rifle, and you couldn't shoot it across the plate by him." (Courtesy of the National Baseball Hall of Fame Library, Cooperstown, New York.)

On October 22, 1938, Josh Gibson, while playing for Santa Clara in the Cuban League, hit a home run at La Boulanger Park, the team's home field. According to eyewitness accounts, the ball ended its flight when it struck the weathervane of a grocery store behind the park. As measured in 1990, when the park and the store were still standing, the distance that Gibson's home run traveled was 704 feet.

After the end of the 1938 Negro League season, the question of blacks in the Major Leagues became a topic among Negro League fans. Ches Washington, a writer for the *Pittsburgh Courier*, sent a telegram to Pittsburgh Pirates manager Pie Traynor that read, "KNOW YOUR CLUB NEEDS PLAYERS STOP HAVE ANSWERS TO YOUR PRAYERS RIGHT HERE IN PITTSBURGH STOP JOSH GIBSON [right] 1B B. LEONARD [left] AND RAY BROWN [center] PITCHER OF HOMESTEAD GRAYS AND S. PAIGE PITCHER COOL PAPA BELL OF PITTSBURGH CRAWFORDS ALL AVAILABLE AT REASONABLE FIGURES STOP WOULD MAKE PIRATES FORMIDABLE PENNANT CONTENDERS STOP WHAT IS YOUR ATTITUDE? WIRE ANSWER." Traynor never replied. (Courtesy of Jeff Eastland.)

Homestead Grays of 1939

For the third straight year, the Homestead Grays won the Negro National league pennant in 1939 with a record of 33 wins and 14 losses. Shown from left to right are the members of the 1939 team: (front row) Jerry Benjamin, Speck Roberts, Lou Dula, Vic Harris, Buck Leonard, Sam Bankhead, and Jelly Jackson; (back row) Josh Gibson, Edsall Walker, David Whatley, Roy Welmaker, Arnold Waite, Henry Spearman, Ray Brown, Jim Williams, Robert Roy Gaston, and Roy Partlow. (Courtesy of the National Baseball Hall of Fame Library, Cooperstown, New York.)

Left-handed hurler Roy Partlow joined the Grays in 1939, bringing with him pinpoint control, a good curve, a batter-baffling drop ball, and a blazing fastball. Although he is remembered as being stubborn, moody, and prone to tantrums on the mound if something went wrong, Partlow was still an important part of the Grays staff, going 6-4 in his rookie season. This is an amazing feat for someone who taught himself to be a pitcher. (Courtesy of Teenie Harris.)

Running to first base during a 1939 game against the Newark Eagles is Henry Spearman of the Grays. Spearman played for the Grays from 1936 through 1939, with a side trip to the Pittsburgh Crawfords in 1937. One of five Spearman brothers who played in the Negro Leagues, Henry was a good fielding third baseman and an average hitter. (Courtesy of the National Baseball Hall of Fame Library, Cooperstown, New York.)

Josh Gibson (left) and Sam Bankhead (center) congratulate Buck Leonard (right) as he scores a run during a game at Yankee Stadium in 1939. That year, Gibson batted .440 for the season and had a slugging average of 1.190. With 19 home runs, he led the league that year. Sam Bankhead hit .292 for the season with three home runs, and Buck Leonard registered a batting average of .403 with eight home runs. (Courtesy of the National Baseball Hall of Fame Library, Cooperstown, New York.)

The 1939 East-West all-star game and its 40,000 fans saw the East team lose by a score of 4-2. The Homestead Grays on the East team were Josh Gibson, Buck Leonard, and Roy Partlow. Gibson can be seen here blocking Kansas City Monarch Henry Milton for the out while Buck Leonard looks on from first base. This game marked Gibson's fifth appearance in the East-West game and Leonard's fourth. (Courtesy of the National Baseball Hall of Fame Library, Cooperstown, New York.)

During the off-season of 1939, Josh Gibson (center) went to Puerto Rico, where he became a player-manager for the Santurce Crabbers. The team also included Bill Byrd (left) and former Pittsburgh Crawford Dickie Seay (right). In a game that his team lost 23-0 to Guayama (led by Satchel Paige), Gibson took the mound as pitcher in an attempt to halt the slaughter. During this trip, Gibson earned the nickname of "Trucutu," a club-carrying comic strip character popular in Puerto Rico at the time. (Courtesy of Luis Alvelo.)

The winners of a fourth consecutive Negro National League pennant were the 1940 Homestead Grays. Shown from left to right are the players that season: (front row) Buck Leonard, Ray Brown, Matt Carlisle, Jelly Jackson, Rocky Ellis, Vic Harris, and Willie Ferrell; (back row) Wilmer Fields, J.C. Hamilton, Josh Johnson, Dave Whatley, Jud Wilson, Jimmy Hicks, Jerry Benjamin, Howard Easterling, Edsall Walker, and unidentified. This team ended the season with a record of 28 wins and 13 losses.

Side-armed pitcher Raymond "Rocky" Ellis joined the Grays in 1940. Originally an infielder, Ellis injured his arm while playing for the Hilldale Daisies, resulting in his move to the mound. Primarily a fastball pitcher, Ellis played for the Philadelphia Stars under manager Jud Wilson in 1939 before both men came to the Grays the next season. In his only season with the Homestead nine, Ellis had a record of one win and one loss. (Courtesy of Luis Alvelo.)

Howard Easterling, from Mount Olive, Mississippi, joined the Grays in 1940 as a third baseman and immediately became an integral part of the team. Easterling was a five-tool player—one who could run, throw, field, and hit for power and average. For the 1940 season, he hit .358 and made his second appearance in the East-West all-star game that year. While he was with the Grays, he hit either in front of or behind the "Thunder Twins," Josh Gibson and Buck Leonard. (Courtesy of Luis Alvelo.)

Dave "Speed" Whatley (shown scoring a run) was back with the Grays in 1940 after having joined the team the previous year. The left-handed hitter was usually in the leadoff spot for the Grays, where his bunting and base-stealing abilities could be put to use. Whatley was the fastest member of the Grays (as long as Cool Papa Bell was not on the team) and hit .290 in 1940. The right fielder stayed with the Grays through the 1944 season. (Courtesy of Teenie Harris.)

Big bad Boojum Wilson (shown connecting for a hit) returned to the Grays in 1940 after having left the team during the 1932 season. A valuable player for his bat, Wilson was a "crude but effective workman" in the field. His method of fielding was simply to stop the ball with whatever part of his body he could and then throw the runner out. This approach worked well for Wilson. According to Jake Stephens, he "could throw out lightning." (Courtesy of the National Baseball Hall of Fame Library, Cooperstown, New York.)

On January 11, 1941, team owners and league officials met to discuss the upcoming season. Decisions were made to limit rosters to 18 players. The league would use the Wilson baseball, with an allowance of two dozen balls each game. Teams would allocate an estimated $65 for each player for two uniforms and a traveling jacket. The players would have to provide their own shoes and sweatshirts. The league officials shown in this picture are, from left to right, as follows: (front row) Bill Laushner, Ed Gottlieb, Seward Posey, Frank Forbes, Eary Brown, and Douglas Smith; (middle row) Charles Brown, Edward Witherspoon, Alex Pompez, Tom Wilson, Effa Manley, Abe Manley, Cum Posey, and J.B. Martin; (back row) Rufus Jackson, Art Carter, Jim Semler, and Jack Waters. (Courtesy of the Art Carter Collection, Moorland-Spingarn Research Center.)

In 1941, the Grays once again became Negro National League champions, much to the consternation of other Negro League teams and their fans. The team ended the season with a record of 25 wins and 17 losses. Shown from left to right are the members of the 1941 squad: (front row) Robert Roy Gaston, Johnny Wright, Buck Leonard, Terris McDuffie, Roy Partlow, Jud Wilson, and unidentified; (back row) J.C. Hamilton, Dave Whatley, Vic Harris, Ray Brown, Chester Williams, Howard Easterling, and Matt Carlisle. (Courtesy of Teenie Harris.)

The Grays showed that they were still a winning team even without Josh Gibson, who spent the 1940 and 1941 seasons playing in Latin America. One of the teams Gibson played for that season was the Veracruz Blues of the Mexican League. The Blues shown, from left to right, are Barney Brown, Josh Gibson, Ray Dandridge, Leroy Matlock, Johnny Taylor, Bill Wright, and an unidentified player. Gibson hit .467 for the Blues in 1940.

The brain trust that turned the Grays into a championship team were the Elks Grand Regional Directors of Athletics. They are, from left to right, Seward Posey, Rufus Jackson, Cumberland Posey, and Russell J. Bowser. Throughout the team's existence, the business end of the operation was handled by Cumberland's younger brother Seward, or "See" as he was known to friends. Seward Posey worked as the Grays' business manager and booking agent.

The saying goes that behind every great man is a great woman. In the case of Cumberland Posey, there were several women—his wife and daughters. They are shown here in the front row, from left to right: Mrs. Posey, Ann Posey, and Mary Posey. Absent is Cumberland's daughter Ethel Posey, who married Grays ace Ray Brown. The great woman who tamed Vicious Vic Harris—his wife, Ada—can be seen behind Mary Posey.

With Gibson still playing *beisbol* in Latin America, Buck Leonard (shown playing first base in a game against the New York Cubans) had to carry the load. Although he hit only .275, Buck was averaging 34 home runs a season at that time. According to one report that appeared during the 1941 season, Leonard was as sure handed in the field as always, making plays that "were way beyond the reach of 99 percent of major league first basemen." (Courtesy of Buck Leonard.)

For Grays pitcher Ray Brown (on left with teammate Josh Gibson), 1941 was a banner year. Brown won 27 consecutive games that year while going 10 and 4 with a 2.72 ERA in league games. During the league playoffs, Brown shut out the New York Cubans in the final game and helped his own cause by getting three hits, including a double and a home run. (Courtesy of the National Baseball Hall of Fame Library, Cooperstown, New York.)

As if to prove the adage that winning never gets old, the Grays dynasty continued apace in 1942. That year, with Josh Gibson back in the fold, the Homesteaders won their sixth consecutive Negro National League pennant. Shown from left to right are the members of the 1942 team: (front row) Dave Whatley, Jud Wilson, Matt Carlisle, Charles Gary, Sam Bankhead, Roy Welmaker, Howard Easterling, and Vic Harris; (back row) Jerry Benjamin, Roy Partlow, Josh Gibson, Johnny Wright, Chester Williams, Ray Brown, unidentified, J.C. Hamilton, Robert Gaston, and Buck Leonard. (Courtesy of Teenie Harris.)

The threat of a $10,000 lawsuit and the possible loss of his house brought Josh Gibson back into the Grays in 1942. Spending the previous two years out of the country did nothing to hurt his fan appeal. He was especially popular with children, as this picture illustrates. Once, when a boy asked Gibson for a broken bat, he answered, "I don't break bats, son. I wear them out." (Courtesy of John Holway.)

The 1942 season also marked the return of Sam Bankhead to the Grays. Bankhead was known as a versatile fielding, base-stealing, and clutch-hitting player. Homestead Grays pitcher Garnett Blair said, "Sam Bankhead to me was an outstanding player. He played shortstop and he would go behind third to get it and throw you out waist high across the diamond. He could not only play short, he could play second, third, he could play outfield, he could pitch, and he could catch. He was all around, so anytime I was pitching I said if that ball goes to Sam Bankhead, fine. There's nothing wrong with that, let it go there because if he got his glove on it, he was going to throw you out."

Bankhead remained with the Grays through the 1950 season, eventually taking over the managerial reins. (Courtesy of Robert McNeill.)

Hall of Famer and former Newark Eagle Monte Irvin remembers an opening day in Newark in the 1940s: "We were leading the Grays 2-0 in the ninth inning with two outs. Jimmy Hill walked [Sam] Bankhead and [Buck] Leonard with Josh Gibson coming up. Leon Day was in the bullpen. He got two quick strikes on Josh and tried to slip a third one by him. He hit it in the center field bleachers to beat us 3-2, before 22,000 disappointed fans. Mrs. Effa Manley [owner of the Newark Eagles] after the game said to Josh, 'You should be ashamed of yourself for spoiling our opener.' Josh replied, 'Mrs. Manley, I break hearts all over the country every summer. If you don't believe me just ask any pitcher.'"

In 1942, for the first time since 1927, a Negro League World Series was played. The game pitted the Homestead Grays against the Kansas City Monarchs, with Satchel Paige, shown here. The Monarchs, much to the surprise of black fans in Pittsburgh, swept the World Series in four games to become world champions of black baseball. The Monarchs pitching had done its job in holding the Grays to a team average of .204, while Buck Leonard hit .166 for the series and Gibson hit .152.

"Nobody ever hit the ball as far as Gibson. I didn't see the one he is supposed to have hit out of Yankee Stadium. But I saw him hit a ball one night in the Polo Grounds that went between the upper deck and the lower deck and out of the stadium. Later that night the night watchman came in and said, 'Who hit that damned ball out there?' He said it landed on the el. It must have gone 600 feet."
—Buck Leonard.

The tragic end of the nation's black home run king began in 1943, when Josh Gibson (shown in 1942 about to cross the plate) began to act increasingly erratic. On January 1, 1943, Gibson fainted and slipped into a coma that lasted for ten days. The Sultan of Swat was diagnosed with a brain tumor, a fact he kept secret from his teammates but related to his sister Annie. The doctors wanted to operate, but Gibson refused, fearing it would leave him in a vegetated state. For the rest of the year, his drinking increased. Repeated breakdowns and chronic headaches landed him in St. Elizabeth Hospital's mental ward in Washington, D.C., for a short time.

In 1943, famed Negro League manager James "Candy Jim" Taylor was brought in to manage the Grays. Vic Harris, who had given up the position in order to work in a defense plant, only played for the Grays when his schedule permitted. Taylor led the Grays to their seventh consecutive Negro National League pennant and their first World Championship. The Grays beat the Birmingham Black Barons in the 1943 Negro League World Series four games to one.

James Thomas "Cool Papa" Bell (shown sliding into third at Griffith Stadium in Washington, D.C.) returned to the Grays in 1943 after spending the previous four seasons in the Mexican Leagues. Bell hit .356 that season as the starting center fielder. According to Quincy Trouppe, the 40-year-old still ran "like he stole something." Despite the legends of his speed, Bell claimed, "I prided myself more as a hitter." (Courtesy of the National Baseball Hall of Fame Library, Cooperstown, New York.)

Forbes Field, longtime home to the Grays, was the site of a pair of monumental home runs by Oscar Charleston and Josh Gibson. Both men hit home runs over the center field wall and out of the ballpark. The center field wall at that time stood 442 feet from home plate.

The stadium was also the site of four Negro League World Series games. It was the site of the second game of the 1942 series, but no games were played there for the 1943 series. The Grays faced the Birmingham Black Barons here in games four and five of the 1944 series. They also faced the Cleveland Buckeyes in game two of the 1945 series. The University of Pittsburgh's Forbes Quadrangle now occupies the site of home plate, but the walls of center field and right field as well as the flagpole base still stand. (Courtesy of the Carnegie Library, Pittsburgh, Pennsylvania.)

A veteran of 21 years of battles in Negro League games, 44-year-old Jud Wilson (right) is shown here with the Grays in 1943. Although no longer a full-time player, Wilson was still an integral part of the Grays clubs as a pinch hitter and occasional starting player. Despite his age, Wilson was still one of the most feared men in uniform. He hit .350 for the Grays in 1943.

Despite his health problems, Josh Gibson (shown with gifts he received for a Josh Gibson Day) had an average of .521 in 1943 and hit three home runs during a game at Washington's Griffith Stadium. One of the balls reportedly landed just two feet from the top of the bleachers in center field. That same season, Gibson hit ten home runs in Griffith Stadium, a feat no Major Leaguer ever accomplished. In his career, "Josh the Basher" twice hit home runs out of Griffith Stadium, both of them over the left field wall. (Courtesy of Jeff Eastland.)

In 1944, the Grays won their eighth consecutive Negro National League pennant and their second consecutive Negro World Championship with another victory over the Birmingham Black Barons. Shown from left to right are the members of the 1944 team: (front row) Jelly Jackson, unidentified, Dave Whatley, Sam Bankhead, Joe Spencer, Vic Harris, Jud Wilson, Ray Battle, and Eddie White; (back row) Edsall Walker, unidentified, Ray Brown, ? Herbert, Spoon Carter, Robert Roy Gaston, Cool Papa Bell, Dave Hoskins, Buck Leonard, Jerry Benjamin, and Candy Jim Taylor. (Courtesy of the Carnegie Library, Pittsburgh, Pennsylvania.)

As this 1944 photograph shows, even the great ones are not always perfect. During a game between the Baltimore Elite Giants and the Homestead Grays, Felton Snow (second from left) and Robert Clarke (far right) catch Buck Leonard in a run down. Josh Gibson (far left) stands on second. That season, Leonard hit .330 and led the league in home runs with eight of them. (Courtesy of the National Baseball Hall of Fame Library, Cooperstown, New York.)

Shown before a game in 1944 are, from left to right, Jelly Jackson, Ray Battle, Eddie Robinson, Sam Bankhead, Josh Gibson, Buck Leonard, Dave Hoskins, Jerry Benjamin, and Cool Papa Bell. Five of the Grays pictured hit over .300 for the season: Gibson with .345, Leonard with .330, Hoskins with .355, Benjamin with .305, and Bell with .373.

Shown holding class for members of the Grays, Candy Jim Taylor brought four decades of baseball experience to the team in 1944. The dapper owner of a candy store in a Chicago hotel (hence the nickname), Taylor was one of five brothers who played in the Negro Leagues. Candy Jim learned the art of managing from his brother C.I. Taylor, who is considered to be one of the greatest managers in the history of Negro League baseball.

Dave Hoskins joined the Homestead Grays as a pitcher in 1944. While Hoskins had good control and a decent fastball, he had an even better bat. He therefore became a two-position player, serving as a regular outfielder for the team. The change seemed to please Hoskins because he excelled at the position and hit .355 for the year. Hoskins remained with the Grays through the end of 1947. He eventually made it to the Major League with the Cleveland Indians in 1953.

Josh Gibson autographs a baseball for Marva Louis, the wife of heavyweight champ Joe Louis, before the 1944 East-West all-star game. Four Grays played in the game that year for the East team: Sam Bankhead (playing both second base and shortstop), Josh Gibson, Cool Papa Bell, and Buck Leonard. The West team won that year by a score of 7-4. (Courtesy of the Moorland Spingarn Research Center, Howard University.)

84

In this 1944 game, pitcher Dave Hoskins (No. 6 for the Grays) attempts a bunt down the third base line. As the first and third basemen of the New York Black Yankees charge, Hoskins pops up. In 1953 and 1954, Hoskins pitched in the Major Leagues with the Cleveland Indians. (Courtesy of the Moorland Spingarn Research Center, Howard University.)

The 1945 *Negro Baseball Yearbook* brought World War II home to the fans of the Negro Leagues by featuring Homestead Gray Spoon Carter and a black soldier on the cover. During the war, nearly 100 Negro League players had their careers interrupted by serving in the armed forces, including 11 Homestead Grays. Of these men, eight served in the army, two in the navy, and one in the army air corps.

In 1945, the Grays won their ninth consecutive pennant. One of the reasons for this success was that its major stars—such as Buck Leonard (shown) and Josh Gibson—were never drafted into the armed forces. A fan could go to a Negro League game and see players like Leonard, Gibson, and Cool Papa Bell, while the white majors were struggling to fill their rosters. This situation made the war years profitable for many Negro League teams. (Courtesy of the Moorland-Spingarn Research Center, Howard University.)

Remembered as one of the Grays' best young pitchers, Garnett Blair posted a 7-1 record in 1945 after returning from the army. Blair played down his contributions to the team when he said, "They say of me, 'Oh, he was a great pitcher for the legendary Homestead Grays.' Listen, anyone's grandmother could have been a great pitcher for the Homestead Grays. Hell, they'd stake you to ten or twelve runs each game without fail. If you could give up less than ten runs a game you'd win."

The 1945 season saw the return of the Pittsburgh Crawfords and Gus Greenlee to Negro League baseball. Greenlee, along with Branch Rickey and others, formed the United States League. Publicly Rickey claimed that the existing Negro Leagues were "in the zone of a racket" and that the United States League's intent was to change this. The truth was that Rickey intended to use the United States League games to scout for a black player he could sign in order to break the white Major League's color barrier. (Courtesy of Teenie Harris.)

Oscar Charleston, who led the famed Pittsburgh Crawfords teams of the 1930s, served as manager for Branch Rickey's own United States League team, the Brooklyn Brown Dodgers. The Brown Dodgers played their home games in Ebbets Field, home the Major League Brooklyn Dodgers. When other Negro League teams came to Brooklyn to play the Brown Dodgers, Rickey had a chance to see the black players his scouts suggested he should sign for his planned integration of the majors. (Courtesy of Teenie Harris.)

Buck Leonard connects for a home run against the Baltimore Elite Giants in a game at Griffith Stadium in 1945. That year, Leonard finished second to teammate Josh Gibson in the home run race—the second year in a row. He hit .375 for the season. During this season, Cumberland Posey selected Leonard as first baseman for his All Time All American team, which Posey drew up at the request of a national periodical. (Courtesy of the National Baseball Hall of Fame Library, Cooperstown, New York.)

On October 23, 1945, the Montreal Royals, a farm team of the Brooklyn Dodgers, announced that they had signed Jackie Robinson to a contract. While most African Americans saw it as a great step forward, Josh Gibson saw it as a great insult. For years, Gibson (shown shaking hands with fans at a Grays game) was one of the greatest drawing cards and players in Negro League baseball. Unbeknownst to Gibson, the Dodgers scout who signed Robinson had looked over Gibson but deemed him to be a less desirable candidate. (Courtesy of the National Baseball Hall of Fame Library, Cooperstown, New York.)

Four
THE BEGINNING OF THE END

On March 28, 1946, Cumberland Posey, the man most responsible for the Grays dynasty, died of lung cancer at Mercy Hospital in Pittsburgh, Pennsylvania. After his death, Posey's brother Seward (center) and his partner Rufus Jackson (far right) took over control of the Grays. Despite the raids by Gus Greenlee in the early 1930s that nearly brought an end to his team, Posey managed to hang on. He built one of the greatest collections of talent in the history of organized sports.

For the first time since 1937, the Homestead Grays of 1946 did not win a pennant. The team finished that season in third place with a record of 27 wins and 28 losses. Members of the team shown here include, from left to right, Vic Harris, Frank Williams, Dan Wilson, Jerry Benjamin, Buck Leonard, Josh Gibson, Sam Bankhead, Cool Papa Bell, Matt Carlisle, and Double Duty Radcliffe. (Courtesy of Robert McNeill.)

Pitcher and first baseman Alonzo Perry joined the Grays in 1946. Primarily known as a curve ball pitcher, Perry pitched his way to a 4-0 record with the Grays that season. He surely would have racked up more wins for the Homestead nine that season, but a disagreement with Rufus Jackson over a sum of money Perry won gambling resulted in him leaving the Grays for the Birmingham Black Barons before the end of the season. (Courtesy of Luis Alvelo.)

The members of the 1946 Grays catching staff are, from left to right, Josh Gibson, Ted Radcliffe, and Ethum Napier. That season, Radcliffe lived up to his name and pulled "double duty" for the Grays. He pitched his way to a record of seven wins and four loses and also spent time in the catcher's role when Gibson, whose physical problems continued to escalate, needed a break. (Courtesy of Robert McNeill.)

The men who patrolled the infield for the Grays in 1946 are, from left to right, Dan Wilson, Luis Marquez, Matt Carlisle, Sam Bankhead, and Buck Leonard. A native of Aguadilla, Puerto Rico, Marquez could play shortstop, second base, third base, or center field with ease, excelling at all of the positions. The season this picture was taken, Marquez hit .309 as the team's starting second baseman. (Courtesy of Robert McNeill.)

Shown from left to right are pitchers Wilmer Fields, Bob Thurman (who also played outfield), and Garnett Blair. After serving in the armed forces from 1943 to 1945, Fields returned to the Grays in 1946 and won 16 games, losing only one. That season, Fields battled the famed Major League pitcher Johnny Vander Meer in an exhibition game. The game turned into a pitcher's duel before Vander Meer finally won by a score of 1-0. (Courtesy of Robert McNeill.)

Three members of the 1946 Grays pitching staff are, from left to right, Harold Hairston, Gene Smith, and R.T. Walker. A pitcher with a good fastball and decent control, R.T. Walker was only an average hitter, making him somewhat unique on the Grays staff. Josh Gibson is said to have teased R.T. about his looks by putting Walker on his "all-ugly" team. (Courtesy of Robert McNeill.)

In 1946, Cool Papa Bell, the 43-year-old former Crawford who led the Negro National League in batting, did not play in the final game. By sitting out, he hoped to increase the chances of Monte Irvin being signed by a Major League team. His sacrifice was not in vain, as Irvin joined the New York Giants in 1949.

In order to give Jackie Robinson a roommate and confidant on the Montreal Royals of 1946, the Brooklyn Dodgers organization also signed Grays pitcher Johnny Wright to a Minor League contract. A talented pitcher with a good fastball and a number of great curve balls, Wright looked to be a good prospect for the Dodgers. However, he could not deal with the off-field pressure. He pitched in only two games for Montreal before being sent to Three Rivers in the Can Am League. Despite having a 12-8 season there, Wright chose to return to the Grays in 1947.

After Johnny Wright failed to last with the Montreal Royals, the Dodgers organization came back to the Homestead Grays in order to find yet another roommate and traveling companion for Jackie Robinson. They signed left-handed pitcher Roy Partlow. Robinson and Partlow did not mesh, however, and despite Partlow's record of 2-0, he was demoted to Three Rivers in the Can Am League. There, he went 10-1 and hit .404. The next season, Partlow returned to the Negro Leagues with the Philadelphia Stars.

"I can remember when [Gibson] couldn't catch this building if you threw it at him. He was only behind the plate because of his hitting. And I watched him develop into a very good defensive catcher. He was never given enough credit for his ability as a catcher. They couldn't deny that he was a great hitter, but they could deny that he was a good catcher. But I know better." —Col. Jimmie Crutchfield.

On the night of January 20, 1947, Josh Gibson arrived at his home in Pittsburgh feeling sick. He lay down in his bed and, with his family gathered around, they waited for the doctor who had been called. According to Gibson's sister Annie Mahaffey in Robert Peterson's *Only the Ball Was White,* they were all "laughing and talking, and then [Gibson] raised up in the bed and went to talk, but you couldn't understand what he was saying, then he laid back down and died right off."

Gibson, who was 35 when he died, had been one of the most popular Negro Leagues players. Baseball has never, and probably will never, see his like again.

The day after Gibson's death, Grays owner Rufus Jackson sent a telegram to the members of the Homestead team. It read, "Pittsburgh Penna Jan 20 1947, Josh Gibson passed 1 am funeral Friday 1pm 2712 Bedford Ave Pgh, Rufus Jackson." That Friday, Gibson was laid to rest in unmarked grave. It was a sorrowful end for a man who was, according to famed Negro League first baseman and manager Buck O'Neil, "our Babe Ruth!"

"They're laying Josh Gibson in the cold . . . cold . . . ground this week! But his brilliant, unequaled deeds as a baseball player will live on forever! For he was a mighty man—Josh Gibson was. He was the answer to a manager's prayer . . . the slugger supreme . . . the home run hitter extra-ordinary . . . the dinosaur of the diamond! He was the 'King of Sock' . . . and he ruled with a majestic splendor. Pitchers quivered in his quake, infielders trembled at his power . . . and outfielders scurried to the hinterlands at his very sight."—Sportswriter Wendell Smith, the *Pittsburgh Courier*. (Courtesy of John Holway.)

The career totals for Josh Gibson (shown at his last East-West all-star game in 1946) were two batting championships in 1943 and 1945 and nine home runs titles in 1932, 1934, 1935, 1936, 1939, 1942, 1943, 1945, and 1946. He appeared in 12 East-West all-star games, in which he batted .459. Gibson's lifetime batting average in official Negro League games was .354 and he had a lifetime average of .412 against white Major League pitching in exhibition games. (Courtesy of Buck Leonard.)

Right-handed pitcher and outfielder Willie Pope joined the Grays in 1947 and worked his way to a six and seven record for the season. He remained with the Grays through the end of the 1948 season before spending 1949 through 1951 in the Canadian League. He then spent five seasons in the Minor Leagues. (Courtesy of Willie Pope.)

97

The brother of Homestead Grays Sam and Garnett Bankhead, Dan Bankhead (left) is shown with Jackie Robinson (center) and an unidentified man. Dan Bankhead became the first African American to pitch in a Major League game when he played with the Brooklyn Dodgers in the 1947 season. During his Negro League career, Dan Bankhead played with the Chicago American Giants, the Birmingham Black Barons, and the Memphis Red Sox.

Shown from left to right are the 1948 Grays: (front row) Sam Bankhead, Luke Easter, unidentified, unidentified, Bob Thurman, Wilmer Fields, and R.T. Williams; (back row) Buck Leonard, Luis Marquez, Garnett Bankhead, Clarence Bruce, unidentified, unidentified, Eudie Napier, unidentified, Frank Thompson, and Vic Harris. This team won the Negro National League pennant, the team's first since 1945, and defeated the Birmingham Black Barons in the Negro World Series. The 1948 season proved to be the Grays' last hoorah. (Courtesy of the Carnegie Library, Pittsburgh, Pennsylvania.)

The name Gibson returned to the Grays lineup in 1949 when Josh Gibson Jr. signed with the team as an infielder. Gibson Jr. had played in the Minor Leagues with the Youngstown Colts in 1948. However, the racial tensions of playing on a white team resulted in a poor performance and he was cut from the team. While he did not have his father's batting eye or power, Gibson Jr. did have excellent speed and stole 20 bases in 68 games one season with the Grays. (Courtesy of Josh Gibson Jr.)

It was the end of an era when the last 1950 Homestead Grays took the field. From left to right are the members of the last Homestead team: Sam Bankhead, unidentified, unidentified, Clarence Bruce, Charles Gary, Lonnie Blair, Dude Richardson, unidentified, unidentified, Shaney Hogan, Buck Leonard, Garnett Bankhead, Josh Gibson Jr., Lester Witherspoon, Jackie Jackson, and unidentified. After the Negro National League folded following the 1948 season, the Grays became an independent team for the 1949 and 1950 seasons. (Courtesy of Josh Gibson Jr.)

Buck Leonard (shown racing to first in a game against the Newark Eagles) set a number of records at the East-West all-star games during his career: most runs scored (9), most home runs (3), most total bases (27), and most RBIs (14). He also tied for most games (13) with Alec Radcliffe. He ranked second in at bats (48) and second for most hits (15). His batting average in East-West competition was .313 while his slugging percentage was .563. (Courtesy of the National Baseball Hall of Fame Library, Cooperstown, New York.)

The Grays' and Crawfords' contribution to baseball did not end with their success in the Negro Leagues. The teams sent 11 former players to the Major Leagues.

PLAYER	MAJOR LEAGUE DEBUT	MAJOR LEAGUE TEAM
Grays		
Luke Easter	August 11, 1949	Cleveland Indians
Luis Marquez	April 18, 1951	Boston Braves
Sam Jones	September 22, 1951	Cleveland Indians
Dave Pope	July 1, 1952	Cleveland Indians
Quincy Trouppe	April 30, 1952	Cleveland Indians
Dave Hoskins	April 17, 1953	Cleveland Indians
Bob Trice	September 13, 1953	Philadelphia A's
Bob Thurman	April 14, 1955	Cincinnati Reds
Crawfords		
Satchel Paige	July 9, 1948	Cleveland Indians
Buster Clarkson	April 30, 1952	Boston Braves
Dave Pope	July 1, 1952	Cleveland Indians

The Negro Leagues continued to have an effect on baseball in Pittsburgh as the Pirates signed former Negro League players from 1954 through 1961.

PLAYER AND YEARS WITH PIRATES	NEGRO LEAGUE CAREER AND MAJOR TEAM
Sam Jethroe, 1954	1938–48 Cleveland Buckeyes
Luis Marquez, 1954	1945–48 Homestead Grays
Curt Roberts, 1954–56	1947–50 Kansas City Monarchs
Lino Donoso, 1955	1947–49 New York Cubans
Chuck Harmon, 1957	1947 Indianapolis Clowns
Gene Baker, 1957–58, 1960–61	1948–49 Kansas City Monarchs
Jim Pendleton, 1957–59	1948 Chicago American Giants
Harry "Suitcase" Simpson, 1959	1946–48 Philadelphia Stars

Curt Roberts—a native of Pineland, Texas—played with the Kansas City Monarchs from 1947 to 1950. On April 13, 1954, he became the first African American to play for the Pittsburgh Pirates.

After he had left the Monarchs, Roberts spent three years in the Minor Leagues with Denver of the Western League. Roberts played with the Pirates for the next three years, his only complete season with the team being 1954. He appeared in 171 Major League games, 164 of them at second base. Roberts had a .223 batting average and a .969 fielding average with the team.

In 1955 and 1956, while not with the Pirates, Roberts played for the Hollywood Stars (Pacific Coast League) and the Columbus franchise (American Association). He played professional ball for various Minor League teams until 1963. (Courtesy of Dick Clark.)

Gene Baker, who played for the Kansas City Monarchs from 1948 through 1950, joined the Pittsburgh Pirates in 1957. The Davenport, Iowa native remained with the Pirates until the end of the 1958 season. After spending 1959 in voluntary retirement, he returned to the team for the 1960 and 1961 seasons. Baker appeared in 182 games for Pittsburgh and had an average of .215. (Courtesy of Sam Lacy.)

Harry "Suitcase" Simpson, who spent 1946 through 1948 with the Philadelphia Stars, ended his Major League career with the Pittsburgh Pirates in 1959. He had started in the Major League in 1951. The Atlanta, Georgia native was nicknamed "Suitcase" because he played for many different teams. He played nine games for the Pirates and hit .267 with the team.

Five
RECOGNITION COMES AT LAST

In 1971, former Pittsburgh Crawford Leroy "Satchel" Paige became the first player inducted into the National Baseball Hall of Fame on the basis of his Negro League career. Paige's Hall of Fame plaque reads, "Paige was one of the greatest stars to play in the Negro Baseball Leagues. Thrilled millions of people and won hundreds of games. Struck out 21 Major Leaguers in an exhibition game. Helped pitch Cleveland Indians to 1948 pennant in his first big league year at age 42. His pitching was a legend among major league hitters." (Courtesy of Pamela Paige O'Neal.)

Josh Gibson moved to Pittsburgh as a child with his family from his hometown of Buena Vista, Georgia, and spent his entire Negro League career with Pittsburgh area teams. He was inducted into the National Baseball Hall of Fame in 1972. His bronze plaque reads, "Considered greatest slugger in Negro Baseball Leagues. Power-hitting catcher who hit almost 800 home runs in league and independent baseball during his 17-year career. Credited with having been Negro National League batting champion in 1936-1938-1942-1945."

Josh Gibson Jr., his family, and his father's sister Annie Mahaffey represented the Gibson family at the induction ceremony. Josh Jr., who accepted the miniature Hall of Fame plaque given to each inductee, called his father's induction "a beautiful thing." (Courtesy of the Moorland-Spingarn Research Center, Howard University.)

Walter Fenner "Buck" Leonard (fourth from left) is shown at his induction into the National Baseball Hall of Fame in 1972. The others are, from left to right, Yogi Berra, Lefty Gomez, Sandy Koufax, and Early Wynn. Leonard, who spent 17 years with the Homestead Grays, was inducted alongside his teammate and fellow "Thunder Twin" Josh Gibson. Leonard's plaque reads, "First baseman of Homestead Grays when team won Negro National league pennant nine years in a row, 1937–1945. Teamed with Josh Gibson to form most feared batting twosome in Negro League baseball from 1937–1946. Ranked among Negro Home Run Leaders. Won Negro National League batting title with .391 average in 1948."

Leonard said in his induction speech, "It was something that I'd never dreamed about, something I'd never think would happen, for we in the Negro Leagues were not even eligible to take part in the Hall of Fame ceremonies." (Courtesy of Buck Leonard.)

James Thomas "Cool Papa" Bell played with the Pittsburgh Crawfords from 1933 to 1938 and with the Homestead Grays in 1932 and from 1943 to 1946. He was inducted into the National Baseball Hall of Fame in 1973. The plaque of the "Winged Mercury of the Negro Leagues" reads, "Combined speed, daring, and batting skill to rank among best players in Negro Leagues. Contemporaries rated him fastest man on the base paths. Hit over .300 regularly, topping four hundred on occasions. Played 29 summers and 21 winters of professional baseball."

Bell had a lifetime .341 batting average in Negro League games and hit .391 against Major League pitching in exhibition games. In 1951, the St. Louis Browns offered Bell a contract to play Major League ball, but Bell declined, saying, "[My] legs were gone. I'd used them up." (Courtesy of the Moorland-Spingarn Research Center, Howard University.)

William "Judy" Johnson was a member of the Homestead Grays in 1930 and 1937 and played with the Pittsburgh Crawfords from 1932 to 1936. In 1975, he became the fifth Negro Leaguer from a Pittsburgh-based team to be inducted into the National Baseball Hall of Fame. His plaque reads, "Considered best third baseman of his day in Negro Leagues. Outstanding as fielder and excellent clutch hitter who batted over .300 most of career. Helped Hilldale team win three flags in row, 1923-24-25. Also played for 1935 champion Pittsburgh Crawfords."

Johnson said at his induction, "I had good times and bad times in my baseball career, but I enjoyed most of them." After pausing for a moment, a teary-eyed Johnson continued, "It'll never get out of me. I guess I'll die with a baseball in my hand. I just love the game." (Courtesy of Todd Bolton.)

Oscar McKinley Charleston—who played with the Homestead Grays from 1930 to 1931 and managed and played for the Pittsburgh Crawfords from 1932 to 1938—became a member of the National Baseball Hall of Fame in 1976. His bronze plaque reads, "Rated among all time greats of Negro Leagues. Versatile star batted well over .300 most years. Speed, strong arm and fielding instincts made him standout center fielder. Later moved to first base. Also managed several teams during 40 years in Negro Leagues."

Charleston retired from baseball in 1950, after having managed the Philadelphia Stars from 1946 to 1950. He returned to manage the Indianapolis Clowns to a championship in 1954. On October 5 of that year, Charleston died after suffering a heart attack. He was just nine days short of his 58th birthday. (Courtesy of Luis Munoz.)

In 1977, Martin Dihigo, who played with the Homestead Grays in 1928, became the first Cuban elected to the National Baseball Hall of Fame. His plaque reads, "Most versatile of Negro League stars. Played in both summer and winter ball most of career. Registered more than 260 victories as a pitcher. When not on the mound he played outfield or infield, usually batting well over .300. Also managed during and after playing days."

A national hero in his native Cuba after his playing days, Dihigo was reportedly forced to fill the position of minister of sports in the government of Fidel Castro. Dihigo died in Cienfuegos, Cuba, on May 22, 1971—three days shy of his 66th birthday. He is buried in Cruces Cemetery in Cruces, Cuba. (Courtesy of Transcendental Graphics.)

A member of the Grays in 1931 and the Crawfords in 1936, Willie Foster—half brother of the founder of the first Negro National League, Rube Foster—joined baseball's elite when he was inducted into the National Baseball Hall of Fame in 1996. "Big Bill's" plaque reads, "Regarded as one of the best left-handed pitchers in Negro League history and also managed several clubs. Devastating side arm delivery made him consistent winner. Instrumental in Chicago American Giants pennants and World Series success in 1926, 1927, 1928, and 1933. Won 26 straight games in 1926 and had 32-3 mark in 1927. Coached baseball at his alma mater, Alcorn A & M College in Mississippi, 1960–1978."

On the day of his induction, Foster's body lay in an unmarked grave in Mississippi, where he had died on September 16, 1978. (Courtesy of John Holway.)

A member of the Homestead Grays in 1932, Willie "the Devil" Wells took his place in the National Baseball Hall of Fame in 1997. His plaque reads, "Combined superior batting skills, slick fielding, and speed on the bases to become an eight time all-star in Negro Leagues. A power hitting shortstop with great hands, ranks among the all time Negro League leaders in doubles, triples, home runs, and stolen bases. Played on three pennant-winning teams with the St. Louis Stars, one with the Chicago American Giants, and one with the Newark Eagles. Overall he played for many Negro League clubs with stints in the Canadian, Mexican, and Cuban Leagues. Player-manager in the Negro Leagues as well." Wells died in Austin, Texas, on January 22, 1989.

Joseph "Smokey Joe" Williams—the ace of the Homestead Grays pitching staff from 1925 to 1932—finally had his talent recognized in 1999, when he was inducted into the National Baseball Hall of Fame. The great hurler's plaque reads, "A star pitcher in the early days of the Negro Leagues. The lanky right-hander with the smooth, overhand delivery was destined for greatness with his pinpoint control, effective change of pace pitch and fastball that traveled with exceptional velocity. Playing for several teams, the New York Lincoln Giants (1911–23) and the Homestead Grays (1925–32) were the primary beneficiaries of his accomplishments. The easy going Texan routinely reached double digits in strikeouts in a game and on August 9, 1930, he struck out 27 Monarchs in a 12-inning contest. Voted the top pitcher in Negro Leagues history in a 1952 poll conducted by the Pittsburgh Courier." (Courtesy of John Holway.)

Wendell Smith (right) is shown with sports writer Sam Lacy (left) and Dan Bankhead. Smith became the first African American to win the J.C. Taylor Spink Award, an honor bestowed on sports writers by the National Baseball Hall of Fame. Smith's 35-year career in journalism started with the *Pittsburgh Courier* in 1937. In 1947, he became the first African American sportswriter to work for a daily paper. Smith's other accomplishments include winning three William Randolph Hearst National Awards for excellence in sports reporting and becoming the first African American boxing radio announcer (1958). Smith died of cancer on November 26, 1972, at the age of 58. He died just one month after his longtime friend Jackie Robinson. (Courtesy of Sam Lacy.)

Josh Gibson is pictured here with a case of "the King of Beers" while he was with Santurce of the Puerto Rican League. Gibson became royalty himself when *The Guinness Book of World Records* declared him the king of home run hitters in North America. Under the heading "Home Runs," Gibson's entry in the book reads, "A North American record of almost 800 in a lifetime has been claimed for Josh Gibson (1911–1947), mostly for the Homestead Grays of the Negro National League, who was elected in 1972 to the National Baseball Hall of Fame in Cooperstown, New York. Gibson is said to have hit 75 round trippers in one season, in 1931, but no official records were kept." (Courtesy of Luis Alvelo.)

Six
THE HILL DISTRICT

An unidentified member of the Pittsburgh Crawfords connects for a hit during a game. The crowd in the stands illustrates how popular baseball was to black America during the time of the Negro Leagues. Due to the segregation of the time, black families had less money to spend on entertainment. However, fans always seemed to find a way to afford admission prices and support their teams. (Courtesy of Teenie Harris.)

Gus Greenlee's Crawford Grill, once the offices of the great Pittsburgh Crawfords teams of the 1930s, burned in 1951. At that time, Greenlee was in the Veterans' Hospital in Aspinwall, Pennsylvania, suffering from an illness that would keep him hospitalized for six months. During his hospitalization, he was also being sued by the Internal Revenue Service for unpaid back taxes. The site of the original Crawford Grill, or the Crawford Grill No. 1, is now the parking lot of the Pittsburgh Civic Center. (Courtesy of Teenie Harris.)

The offices of the Pittsburgh Crawfords were in the first Crawford Grill, also known as the Crawford Grill No. 1, located at 1401 Wylie Avenue. The Crawford Grill No. 2, which is shown here in 1994, is located at 2141 Wylie Avenue. The Crawford Grill No. 2, a lasting link to Pittsburgh's illustrious black history, is the last surviving vestige of the once vast Greenlee Empire that changed the face of black baseball.

Like the African American sections of every major city in the country, the Hill was a city within a city. Businesses—such as the Roosevelt Theater, the Roosevelt Barber, and the Palace of Sweets—were black-owned and black-operated establishments that thrived during the heyday of the Negro Leagues. By the 1960s, once thriving black areas began to decline, a trend that continues today. (Courtesy of Teenie Harris.)

This view of the Hill, looking out from the Crawford Grill No. 2 on Wylie Avenue, shows evidence of the decline that has occurred in the past decades. Once Pittsburgh's equivalent of New York's Harlem, the Hill was the place to be when a Negro League team was in town. The Hill offered the finest dining establishments, nightclubs, and theaters.

On September 23, 1996, a Pennsylvania Historical and Museum Commission plaque marking the career of Josh Gibson was unveiled on Bedford Avenue in Pittsburgh. The plaque was on the sidewalk in front of Ammon Field, former home field of the Homestead Grays, and Macedonia Baptist Church, the site of Gibson's funeral. Josh Gibson Jr. (center, next to his son Sean, left) represented the Gibson family at the unveiling. Also present were former Negro League players Willie Pope and Rev. Harold Tinker as well as Pittsburgh Pirates representative Al Gordon. (Courtesy of Josh Gibson Jr.)

Seven
WEEP YE NOT FOR THE DEAD

On February 25, 1951, the great Smokey Joe Williams—who shined as a member of the Homestead Grays from 1925 to 1932—died in New York City. Just after his induction to the National Baseball Hall of Fame in 1999, his grave site was found at Lincoln Memorial Cemetery in Suitland, Maryland, outside of Washington, D.C., the second home of the Homestead Grays.

William Augustus "Gus" Greenlee died on July 7, 1952, and was buried in Allegheny Cemetery in Pittsburgh. By the time of his death, Greenlee—who was once the most powerful man in black Pittsburgh and the king of black baseball in the 1930s—was being investigated by the Internal Revenue Service for delinquent taxes. Despite his abrupt fall from grace as the "King of the Hill District," Greenlee will always be remembered for his role as the founder of the second Negro National League and the East-West all-star game.

Jud Wilson (shown about to tag home behind Sam Bankhead) retired from baseball in 1946 and remained in the Washington, D.C. area, where he worked as part of the construction crew that built the city's Whitehurst Freeway. Wilson, who had suffered from epilepsy during the latter stages of his career, died in D.C. on June 26, 1963 at the age of 64. (Courtesy of the National Baseball Hall of Fame Library, Cooperstown, New York.)

After retiring from baseball in 1950, Sam Bankhead stayed in the Pittsburgh area, working for the sanitation department. Eventually Bankhead took a job as a porter at the William Penn Hotel in Pittsburgh. While working at the hotel, on July 24, 1976, Bankhead and a fellow worker got into an argument. The 71-year-old Bankhead reportedly turned his back on the other man, who then took out a gun from his locker and fatally shot the former ball star. (Courtesy of John B. Holway.)

121

In July 1975, Pedro Zorilla (former owner of the Santurce team of the Puerto Rican League) and Ted Page (former Crawford and Gray) visited Josh Gibson's grave in Pittsburgh's Allegheny Cemetery. They discovered that the grave was marked only by a numbered metal disk, nearly three decades after Gibson's death. Page therefore decided to raise money for a headstone and was soon given a $100 donation by Pittsburgh Pirate Willie Stargell. When news of the endeavor reached Major League Commissioner Bowie Kuhn, he informed Page that his office would pay for a stone and all related expenses.

After retiring from baseball in 1937, Judy Johnson went to work for the Continental Can Company in Wilmington, Delaware, and helped his brother run a general store. He later returned to professional baseball as a scout for the Philadelphia A's, the Philadelphia Phillies, and the Milwaukee Braves. Johnson was also a member of the Hall of Fame committee that elected the first nine Negro League players into baseball's hallowed halls. Johnson died from a stroke in 1989 at the age of 88.

On March 7, 1991, Hall of Famer James Thomas "Cool Papa" Bell (shown here in 1983 at the age of 80), died in St. Louis just months after the death of his wife. After retiring from baseball in 1950, Bell worked as a custodian and security guard at city hall in St. Louis until 1970. Throughout the rest of his life, he remained one of the most popular veterans of the Negro Leagues. (Courtesy of James Bell.)

Former Pittsburgh Crawford and famed photographer Charles "Teenie" Harris died on June 13, 1998, in Monroeville, Pennsylvania, at the age of 89. He was buried in Homewood Cemetery. By the time of his death, Harris had achieved celebrity status on the international art scene for his photographs. In 1997, the Carnegie Museum of Art in Pittsburgh acquired a collection of 4,500 of Harris's photographs. (Courtesy of Elias Dudash.)

In 1994, at the 65th all-star game at Three Rivers Stadium, Major League baseball named Phil Rizzuto (American League) and Walter "Buck" Leonard (National League) as honorary captains. It was the first time that a former Negro League player had been appointed captain of a Major League all-star team. "Just when I thought that all my baseball memories were behind me, I now have one of the greatest thrills as honorary captain," said Leonard. "I am very grateful to the National League and Len Coleman [league president] for this honor."

Buck Leonard died on November 29, 1997, at the age of 90 from complications resulting from a stroke he had suffered in 1986. After retiring from baseball, Leonard returned to his hometown of Rocky Mount, North Carolina, where he worked as a truant officer before opening his own successful real estate office. Buck Leonard Park is located near the area of Rocky Mount known as "Little Raleigh," where Leonard grew up. (Courtesy of Al Gordon and the Pittsburgh Pirates.)

Eight
ONLY MEMORIES REMAIN

"We played an exciting brand of baseball, and we entertained the people who came to see us play. But we weren't entertaining 'cause we were clowning around out there. No sir! We were entertaining 'cause we took the game serious and played good solid baseball." —Ted "Double Duty" Radcliffe.

"Only the love of the game kept baseball going in the black leagues." —Col. Jimmie Crutchfield.

"Because of baseball, I smelled the rose of life." —Cool Papa Bell. (Courtesy of Teenie Harris.)

"If Josh Gibson had been in the big leagues in his primes, Babe Ruth and Hank Aaron would still be chasing him for the home run record." —Judy Johnson.

"He was the most awesome hitter God ever put breath in." —Ted "Double Duty" Radcliffe.

"I played with Willie Mays and against Hank Aaron. They were tremendous players, but they were no Josh Gibson." —Monte Irvin.

"The thing I don't like particularly is that people call my father the black Babe Ruth. I'd prefer it if they just called him Josh Gibson." —Josh Gibson Jr.

"Man, when I come to the plate, I'm in scoring position." —Josh Gibson. (Courtesy of the National Baseball Hall of Fame Library, Cooperstown, New York.)

"Buck Leonard was the equal of any first baseman who ever lived. If he'd gotten the chance to play in the major leagues, they might have called Lou Gehrig the white Buck Leonard." —Monte Irvin.

"He had a real quick bat, and you couldn't get a fastball by him. He was strictly a pull hitter with tremendous power." —Roy Campanella.

"[Leonard was] a flashy consistent, fielding genius, a superman at the plate and a player of the old school, who eats and dreams baseball." —The *Pittsburgh Courier*.

"I was talking about Robinson, Campy, and Newk making it with Brooklyn. I'll never forget Buck's eyes filling with tears when he said, 'But it's too late for me.'" —Brooklyn Dodgers scout Elwood Parsons.

"Buck Leonard was outstanding as a ballplayer and as a man. He was respected by everybody, and was sort of a father image for younger players on the team." —Josh Gibson Jr. (Courtesy of the Moorland-Spingarn Research Center, Howard University.)

"Cool Papa was a noble man, an elegant man. He was a great competitor as a player, but I was impressed most with the nobility of the man." —Bob Broeg of the *St. Louis Post-Dispatch.*

"And with his glove on, James Thomas Bell often turned the fans attention from Paige and Gibson. For a quarter of a century, he was the most famous fly hawk in the Negro Leagues." —Ken Smith in *Baseball's Hall of Fame.*

"It's impossible for anyone to be a better ballplayer than Oscar Charleston." —Grantland Rice in his column *No Greater Ballplayer.*

"He didn't have a weakness. When he came up, we just threw and hoped like hell he wouldn't get a hold of one and send it out of the park." —Dizzy Dean.

"He can cover more ground than any man I have ever seen. His judging of fly balls borders on the uncanny." —Ben Taylor.